AUSTRALIA'S WEST

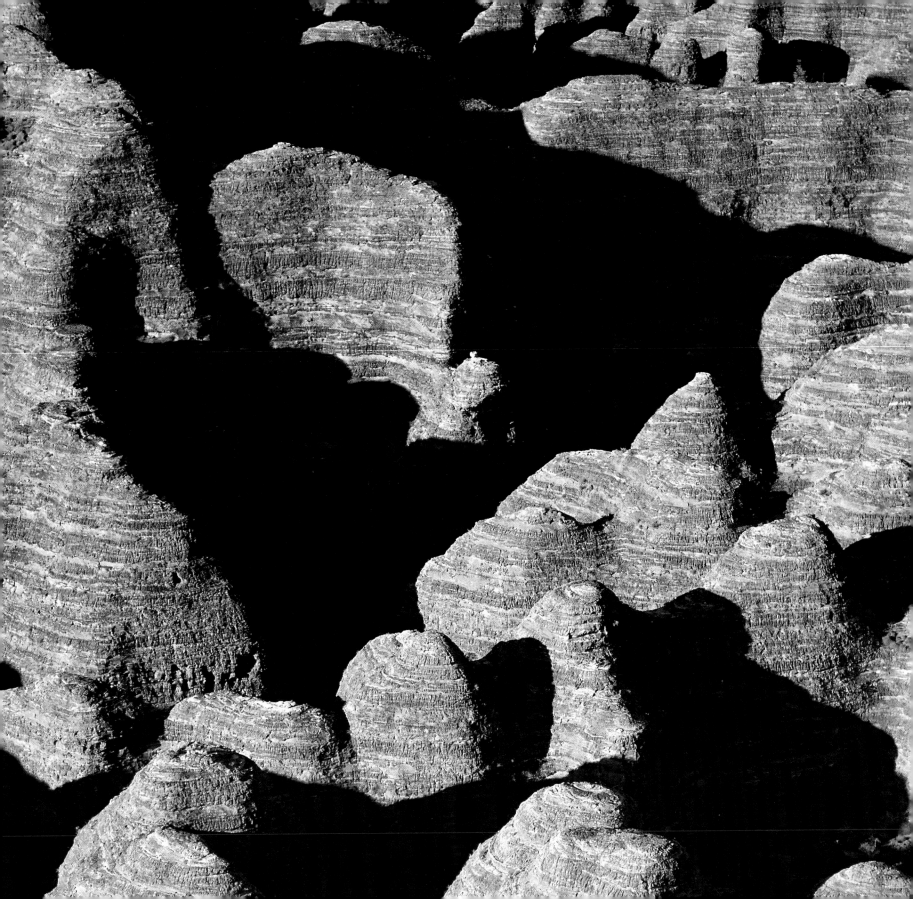

AUSTRALIA'S WEST

RICHARD WOLDENDORP

FREMANTLE ARTS CENTRE PRESS

First published 1997 by
FREMANTLE ARTS CENTRE PRESS
193 South Terrace (PO Box 320), South Fremantle
Western Australia 6162.

Reprinted 1998.

Consultant Editor B R Coffey
Designer John Douglass.
Production Manager Cate Sutherland

Typeset by Fremantle Arts Centre Press
and printed by South Wind Production, Singapore

National Library of Australia
Cataloguing in publication data

Woldendorp, Richard, 1927
Australia's west.

ISBN 1 86368 217 1.

1. Western Australia - Pictorial works. 1. Title.

919.41

The State of Western Australia has made an investment in this project through the
Department for the Arts.

Frontispiece: The Bungle Bungle, Purnululu National Park, East Kimberley.

ACKNOWLEDGEMENTS

I would like to thank my wife Lyn and Jenny, my assistant, for their support in the photographic selection for this book, and also my friend Anne Ameling for her editing skills.

There are many people with an interest in the beauty of our landscape who have helped in getting access to some of the key photographic locations, especially farmers and pilots with their special interests and skills. Thanks to all.

Richard Woldendorp

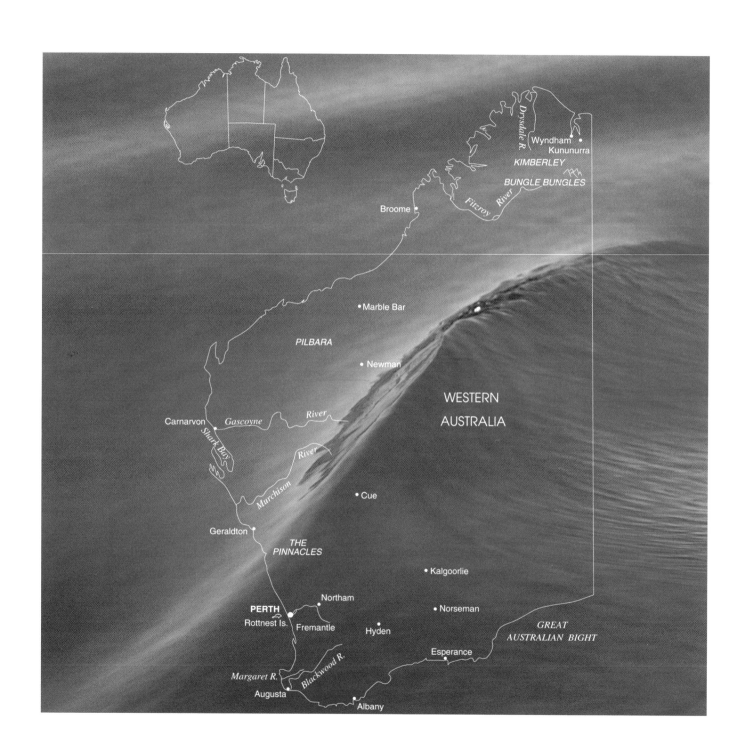

Wyndham
Kununurra
KIMBERLEY
BUNGLE BUNGLES

Drysdale R.

Fitzroy River

Broome

Marble Bar

PILBARA

Newman

WESTERN
AUSTRALIA

Carnarvon *Gascoyne* *River*

Shark Bay

River

Murchison

Cue

Geraldton

*THE
PINNACLES*

Kalgoorlie

Northam
Norseman

PERTH
Rottnest Is. Fremantle Hyden

*GREAT
AUSTRALIAN BIGHT*

Esperance

Margaret R. *Blackwood R.*

Augusta
Albany

AUTHOR'S NOTE

Western Australia is the largest State of the Australian continent; in fact it encompasses one-third of the whole country. It is also the most sparsely populated of all the States.

One cannot help but be impressed, not only by the vastness of the State, but also by the natural landscapes that make it such a unique and fascinating area. There are few places left, particularly in the Western world, where one can so easily leave behind cities, freeways and the man-made environment.

When travelling by motor car through the State, the visitor may be excused for finding the outback monotonous or repetitive. Yet this 'sameness' is its strength. Millions of years of evolution have gone into the creation of forms of existence that have successfully adapted to extremely harsh conditions. This environment with its enormous spaces is unique in our present-day, over-populated world.

Through these pictures I hope to give an impression of the variety of this landscape and its seasonal changes, as well as to show something of man's encroachments upon it. We should tread lightly in this fragile environment, wonder at its strength and beauty, be inspired by it and develop our own environments in harmony with it. Sadly, this has not always been the case.

All the photographs in this book are 'as found', not manipulated by computer or any other means. For me, to do otherwise would be to insult the natural beauty of the Western Australian landscape which truly needs no such enhancement.

Richard Woldendorp

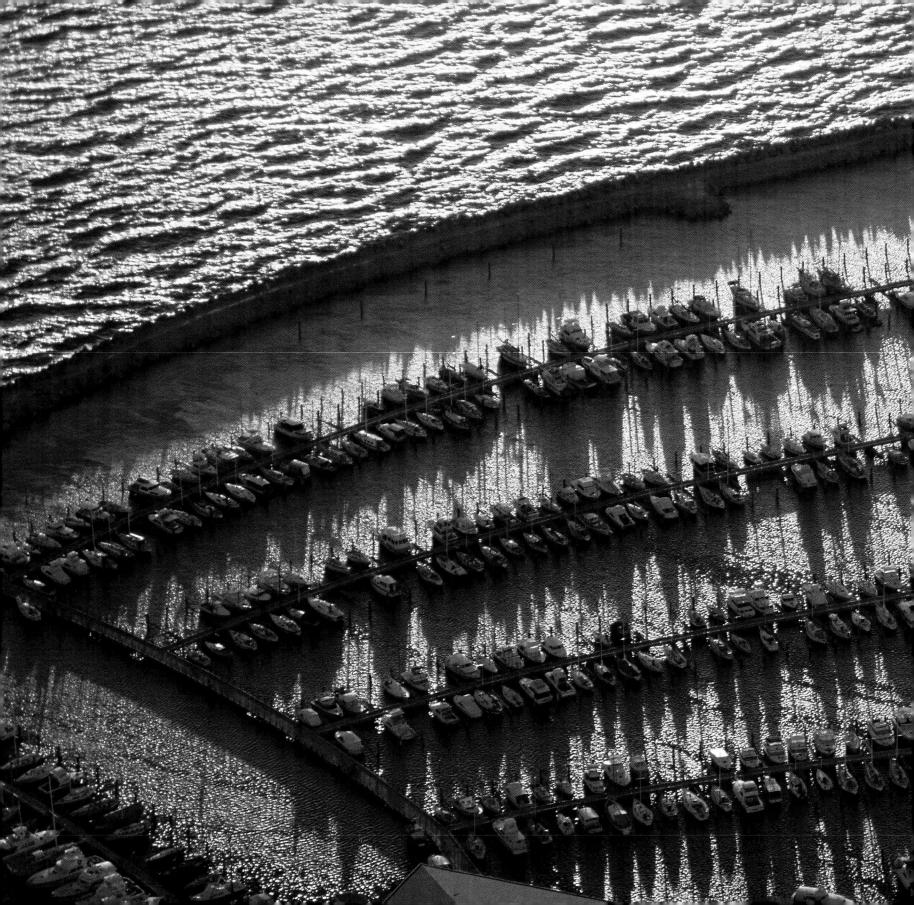

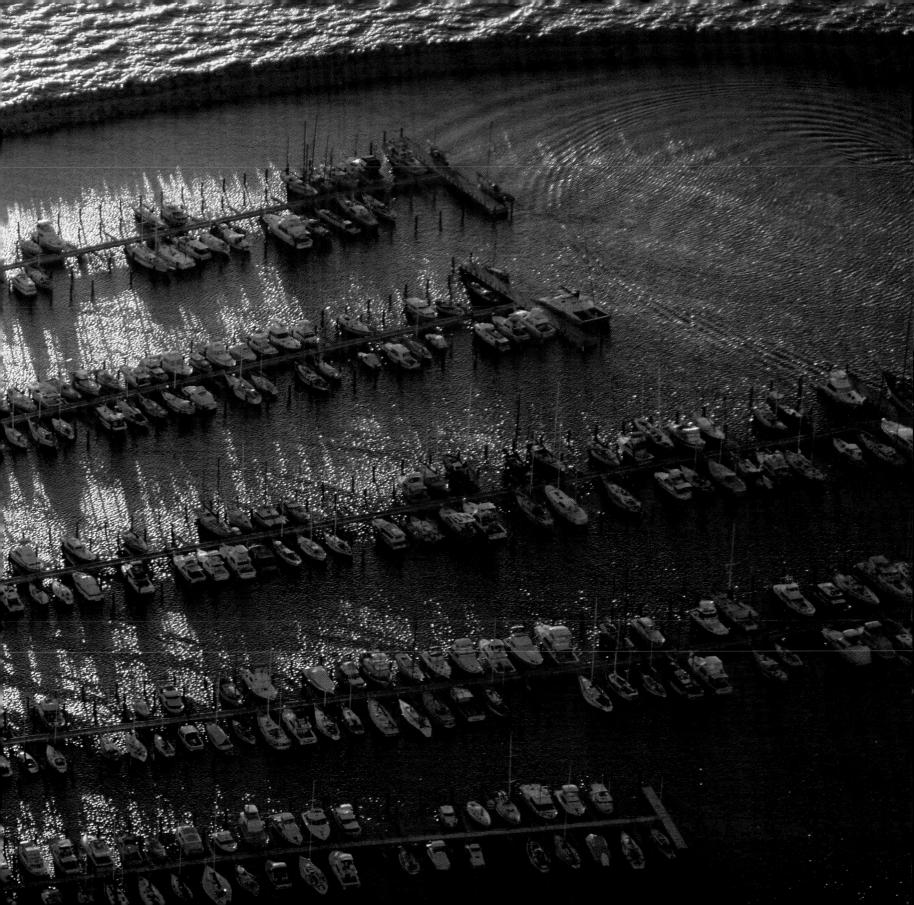

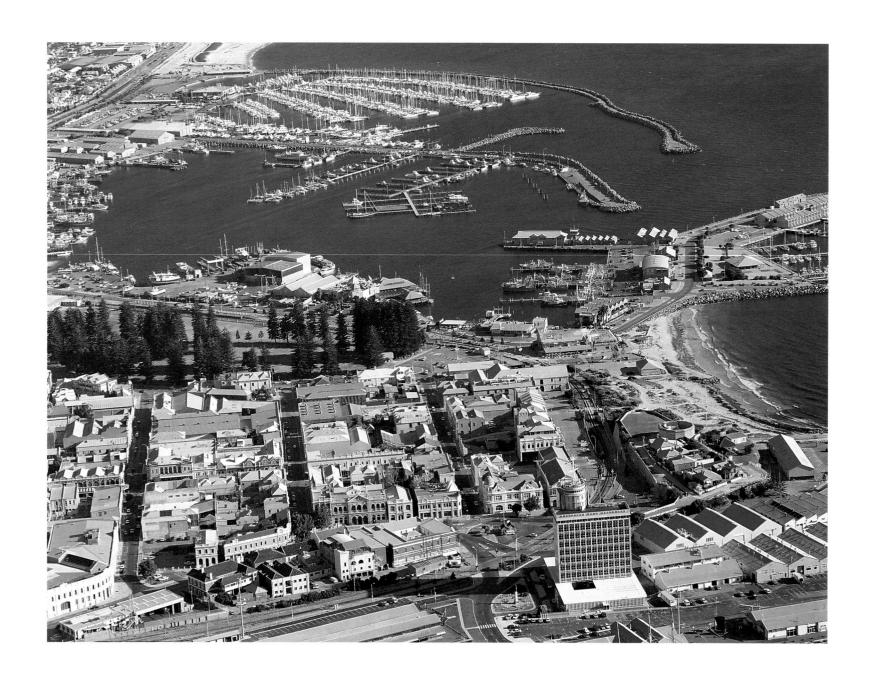

Overleaf: Fremantle Sailing Club and marina at sunset.

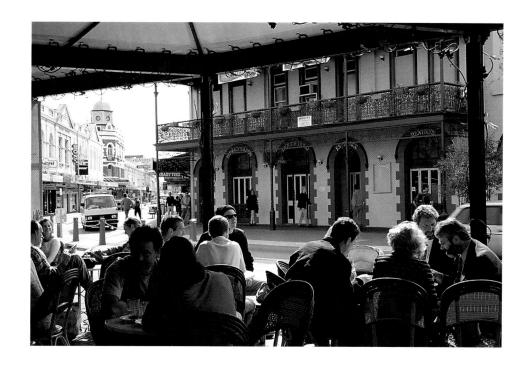

Fremantle, historic gateway to Western Australia. This lively port has retained much
of its 19th century character by the conservation and restoration of its old buildings. It is
a multicultural town on a human scale. Walking is the ideal way to see its sights, and to
wind up the tour there is the well-known 'cappuccino strip' in South Terrace where the
visitor can enjoy coffee as it should be made, as well as food from every nation.

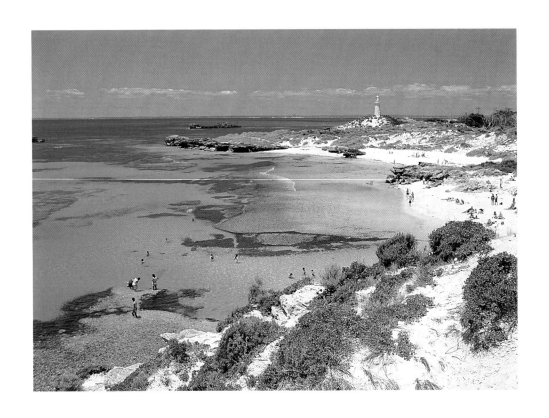

Rottnest Island, some twelve kilometres west of Fremantle, was named by the
Dutch explorer, Vlamingh, who mistook for rats the small native marsupials (now known as
quokkas) that he found there. 'Rats nest' or Rottnest, as it became, saw some dark days as an
Aboriginal penal colony but is now a favoured holiday playground.

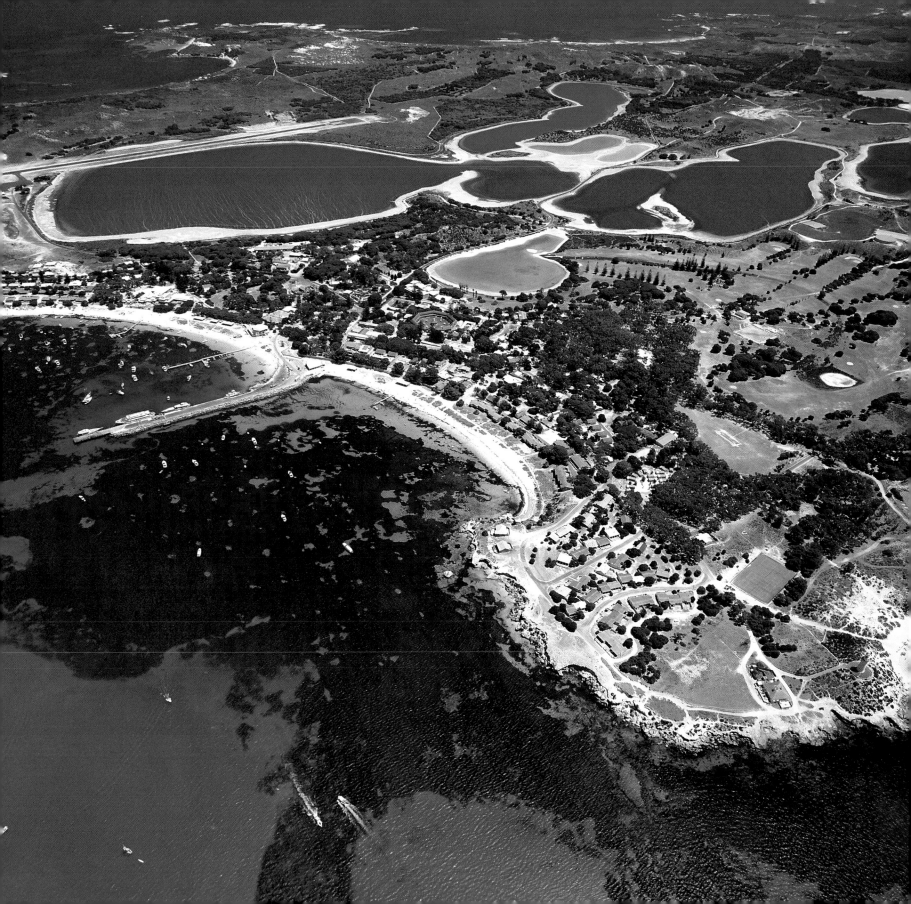

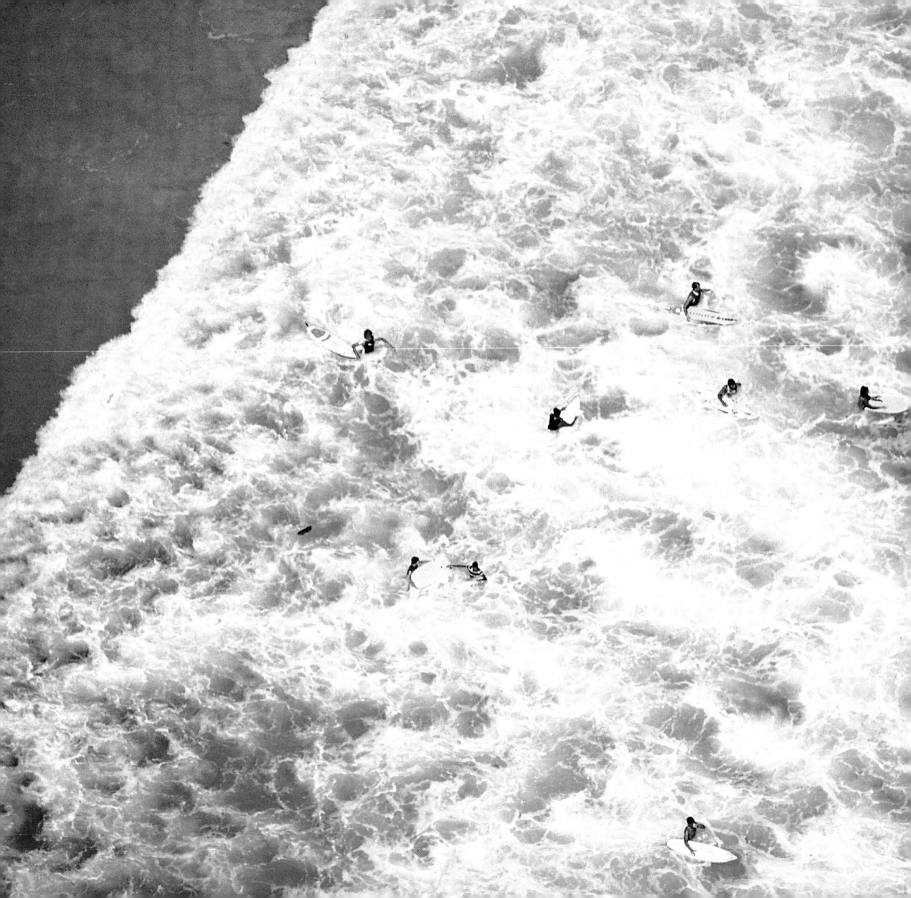

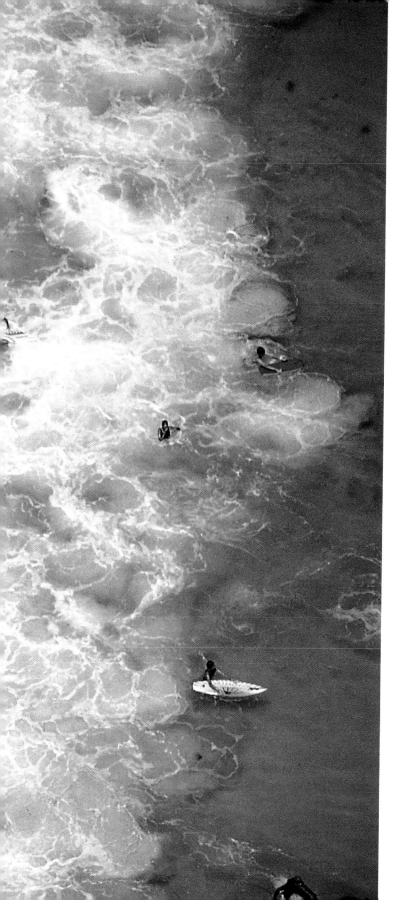

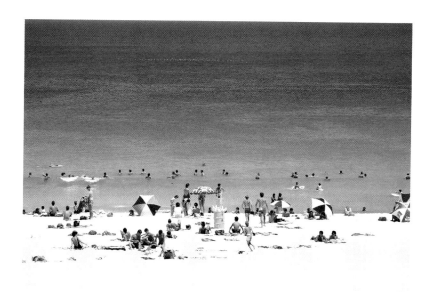

Turquoise seas and dazzling white sands make up a string of fine beaches that fringe the coast from Mandurah in the south to Yanchep in the north.

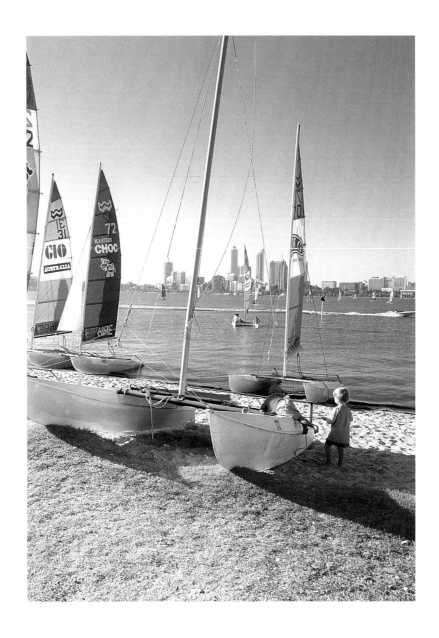

The urban scene from Perth to Fremantle is dominated by the broad
stretches of the Swan River. Water sports can be enjoyed right on the
city's doorstep.

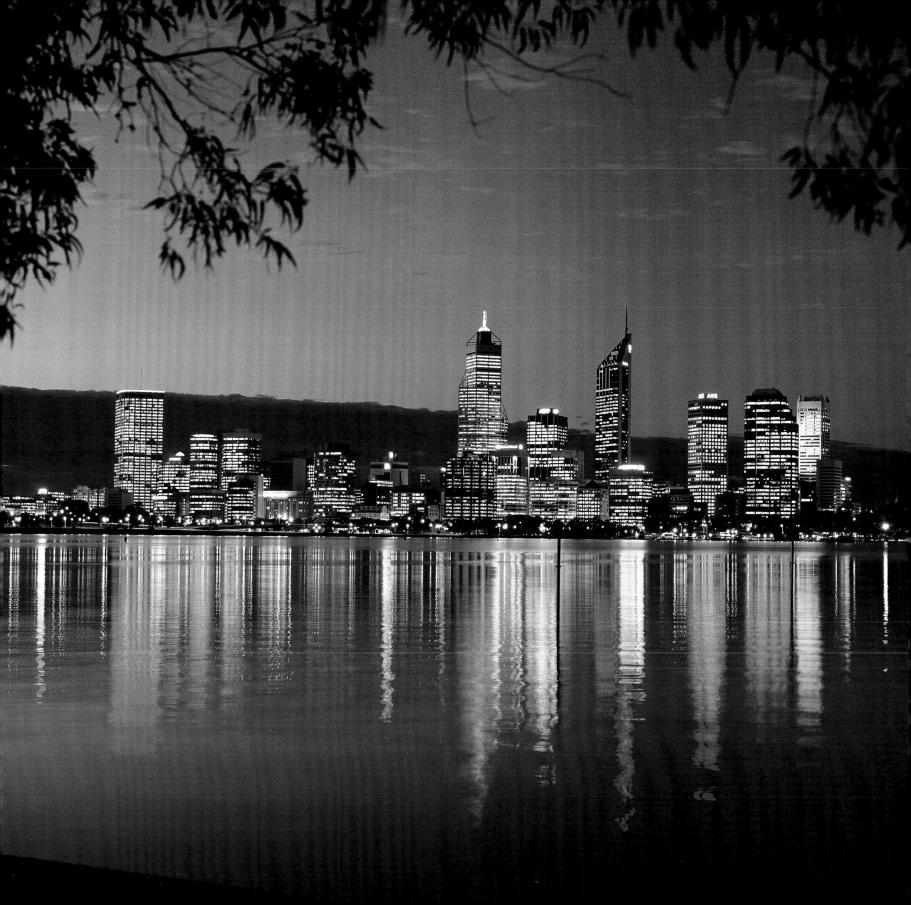

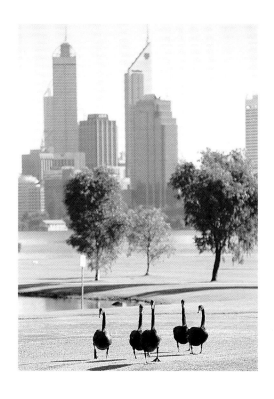

Perth was founded as the capital of
Britain's Swan River Colony by Captain
James Stirling in 1829. An even earlier
visitor was the Dutch sailor Willem de
Vlamingh, whose statue can be seen on the
foreshore. In 1696 he and his crew were
the first Europeans to explore the Swan
River. They marvelled at the black swans
they saw there and trapped a number to
take back to the Netherlands, where all
swans were white. The black swan is now
the emblem of the City of Perth.

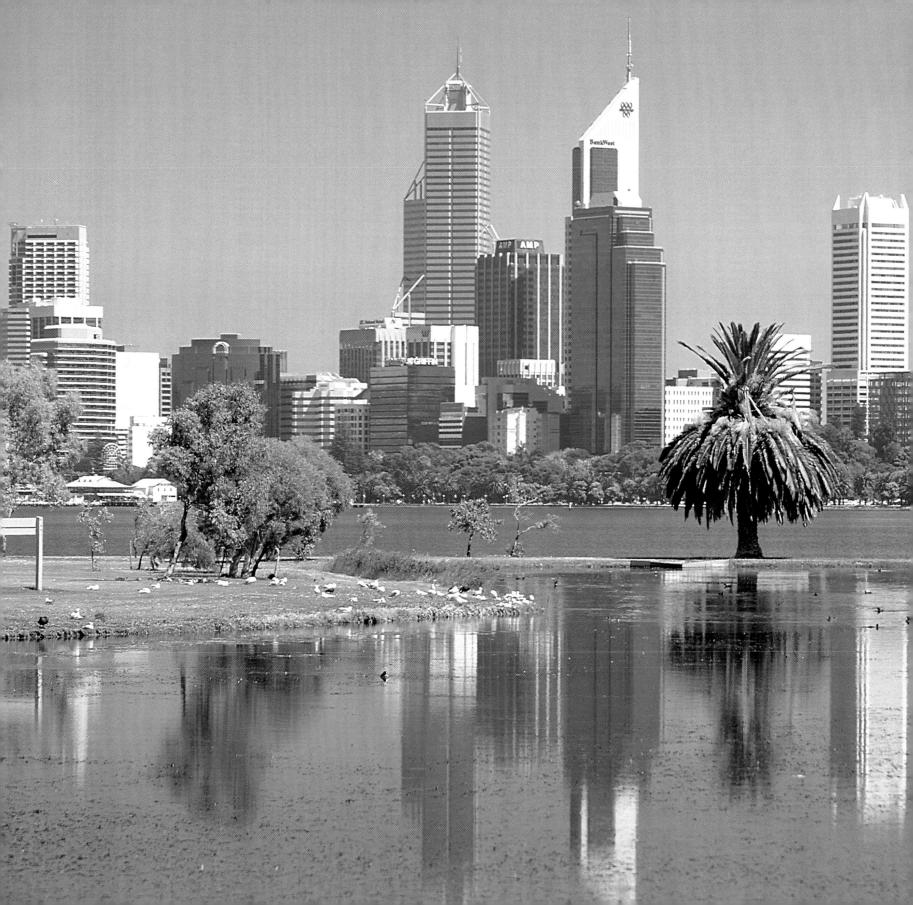

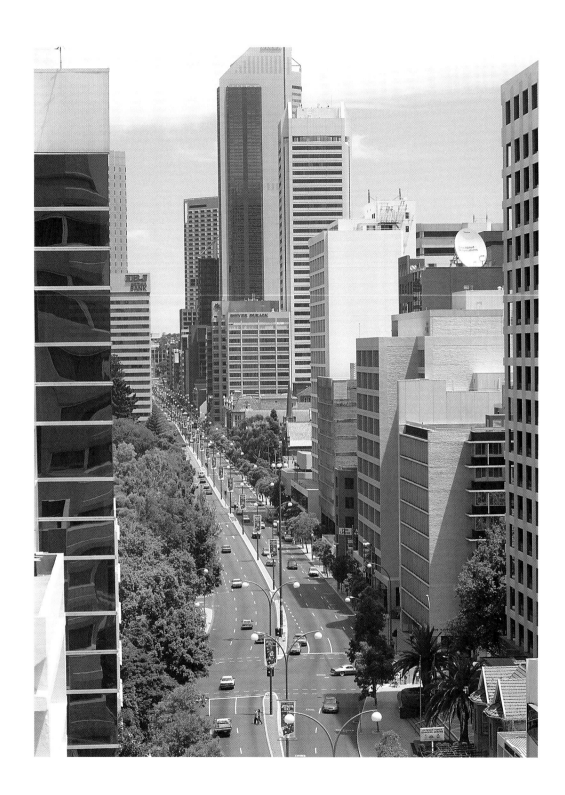

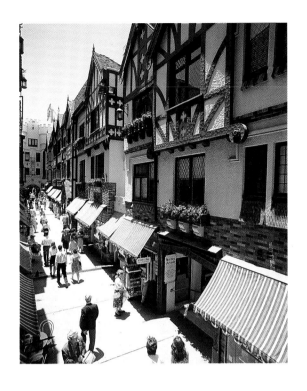

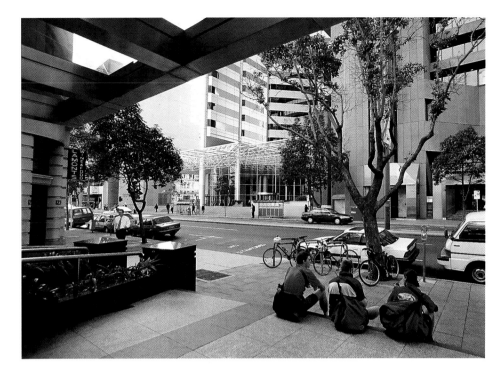

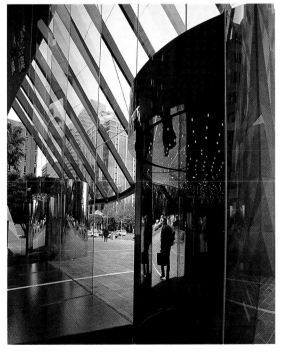

Perth City centre.

St George's Terrace, here viewed from
Adelaide Terrace, is the main business
avenue.

The architecture of the city is a harmonious
blend of old and new. The antique Tudor
style of London Court is balanced by the
cool space of the lobby of the modern QV1
building.

Bike couriers take a break.

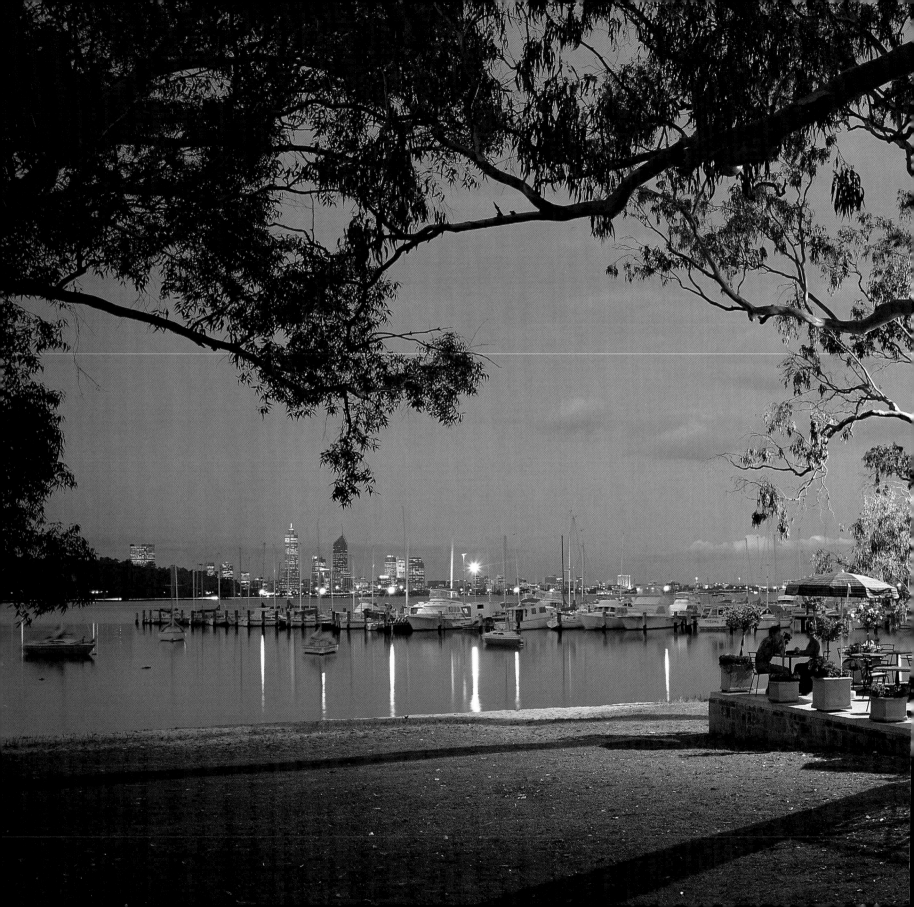

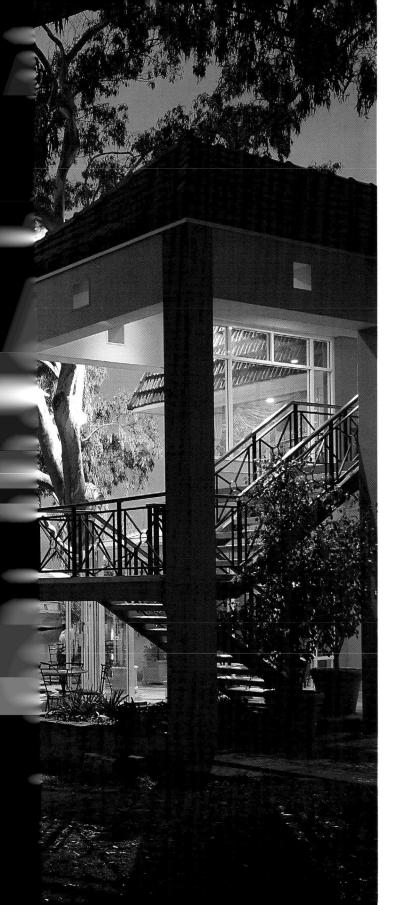

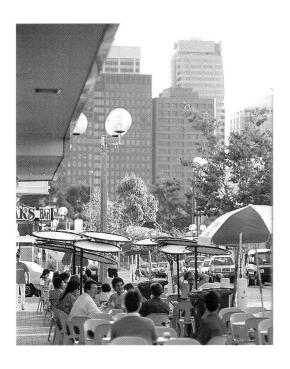

Alfresco dining in Northbridge, Perth's main cafe and nightlife district.

A restaurant on the water at Matilda Bay, Perth city in the distance.

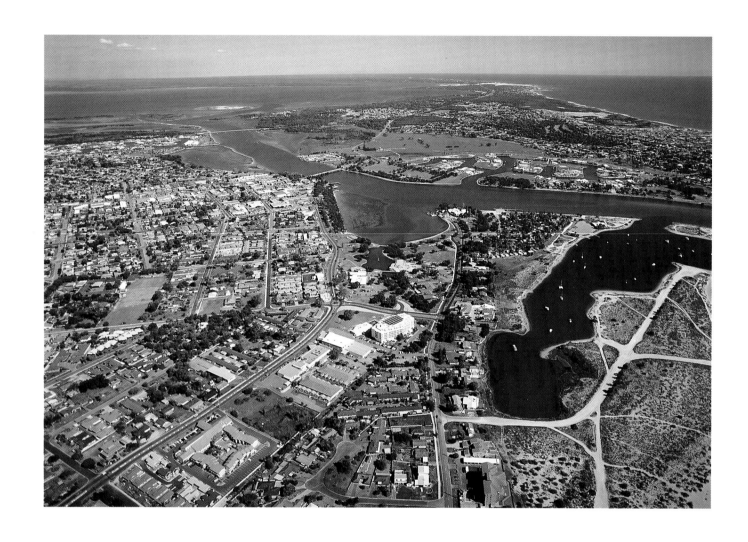

Mandurah, a fast-growing city and popular holiday spot on the south coast of Perth.

The still, shallow waters of Mandurah Estuary support a wide range of birdlife.

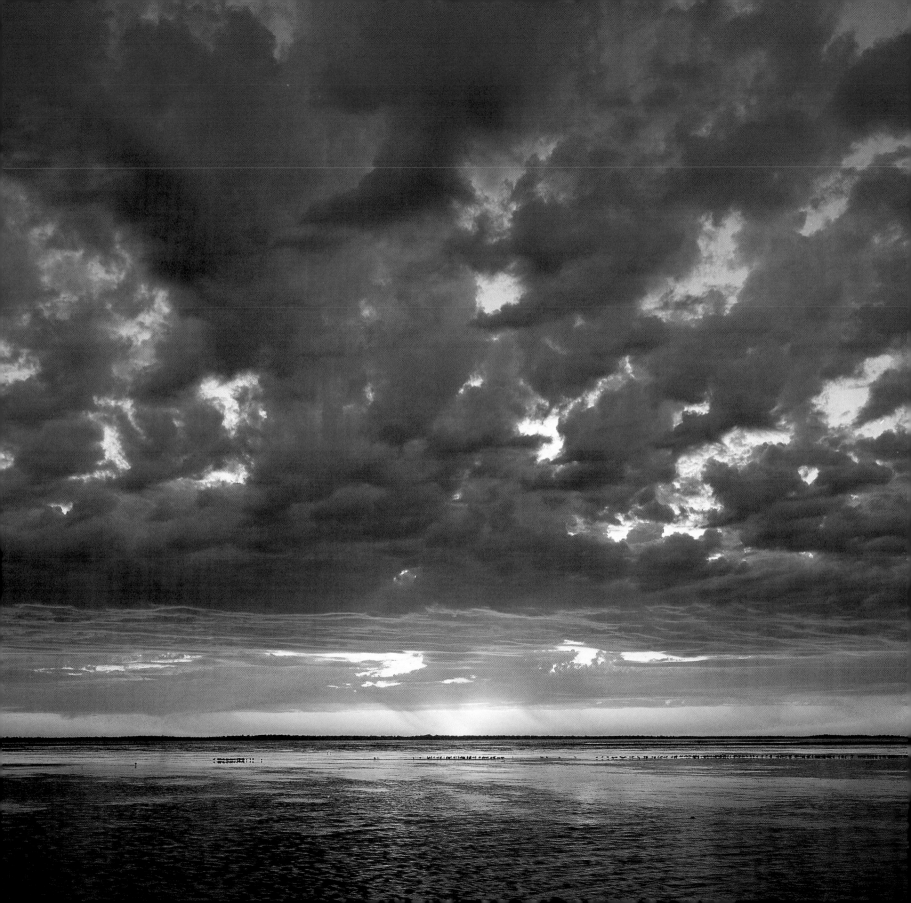

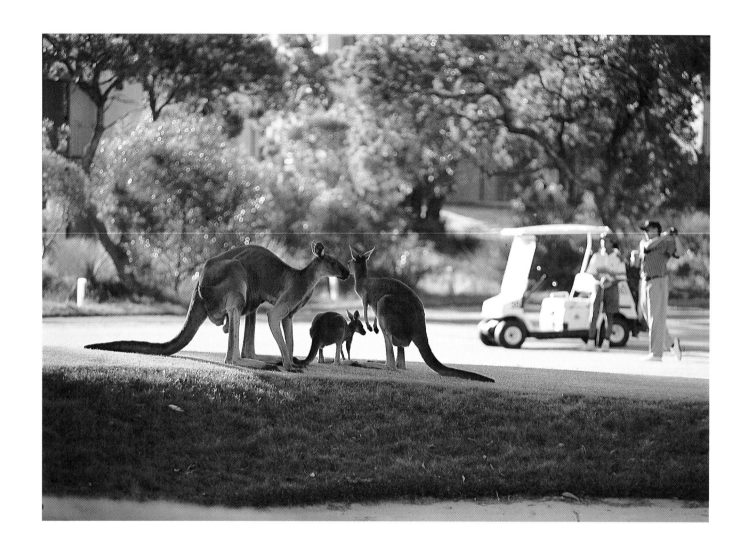

Close encounters — golfers and kangaroos share the green at Joondalup Resort Golf Course.

A misty morning and a hot-air balloon lifts off over the Avon Valley, Northam.

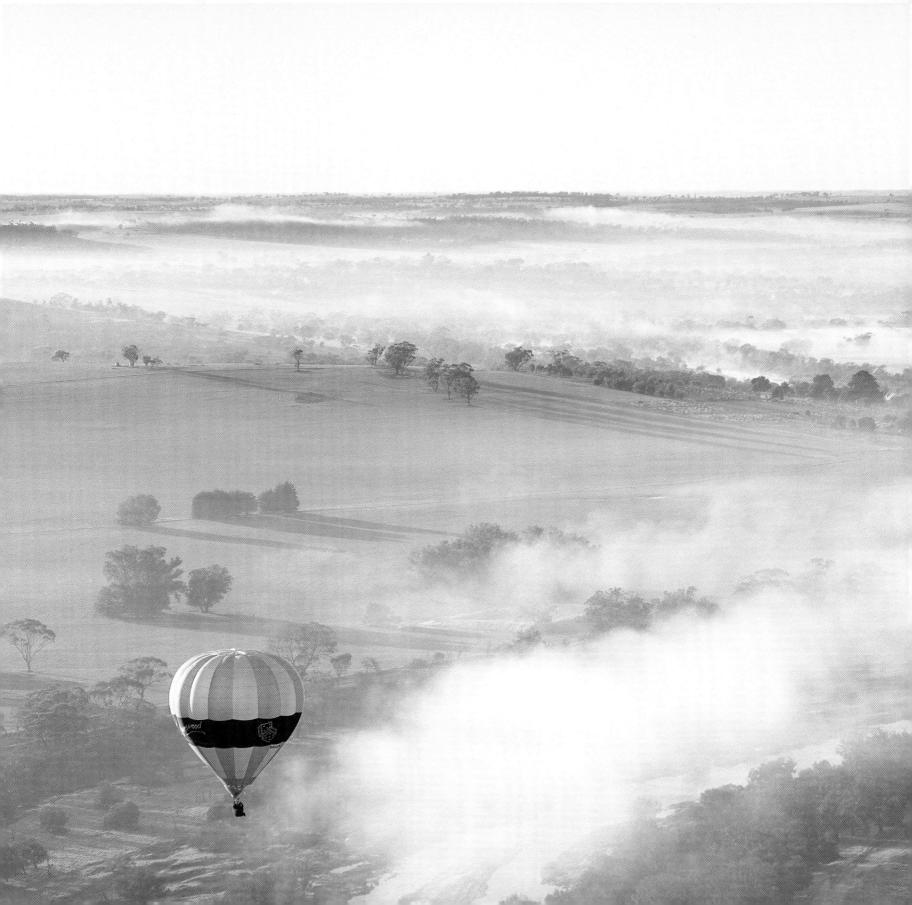

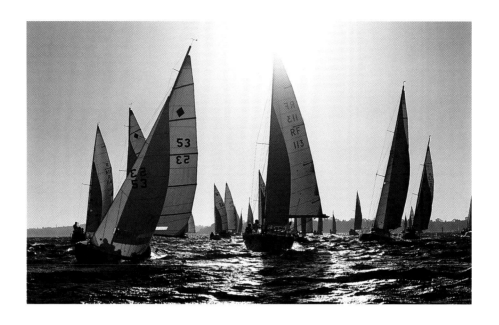

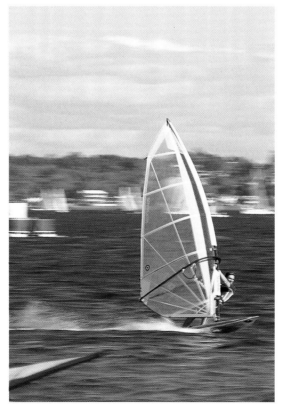

Twilight sailing on the Swan River. Windsurfing offers a more individual alternative.

Replica of Captain Cook's ship, the *Endeavour*, on a shining sea off Fremantle.

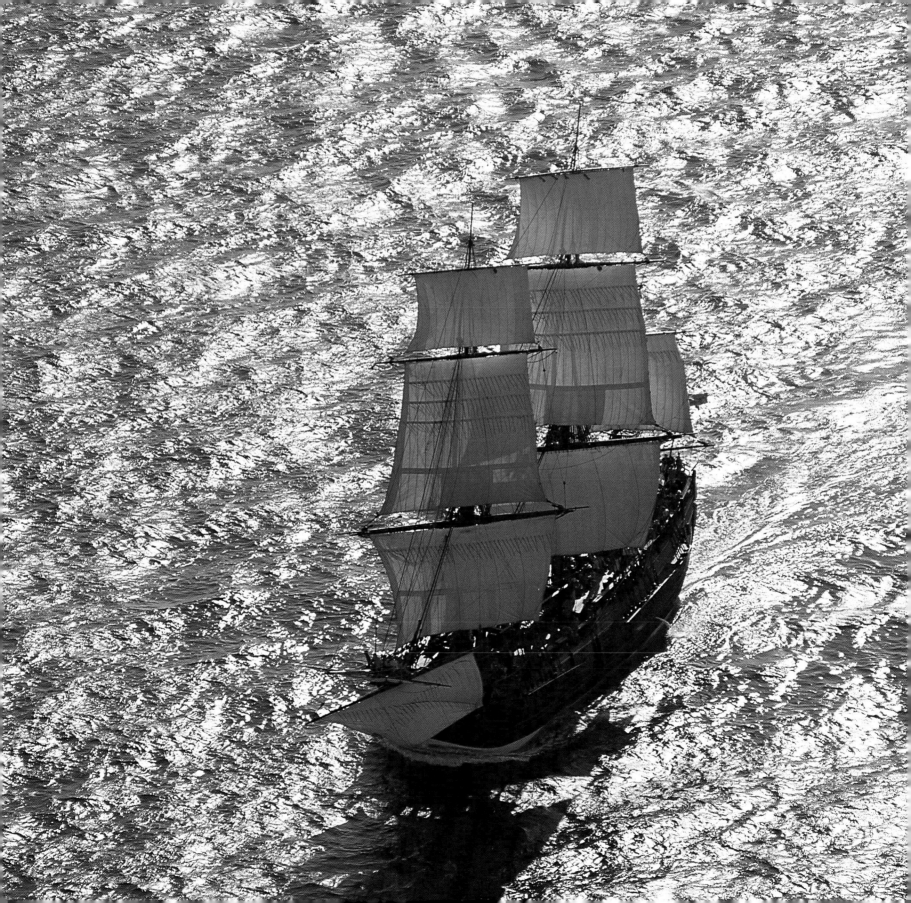

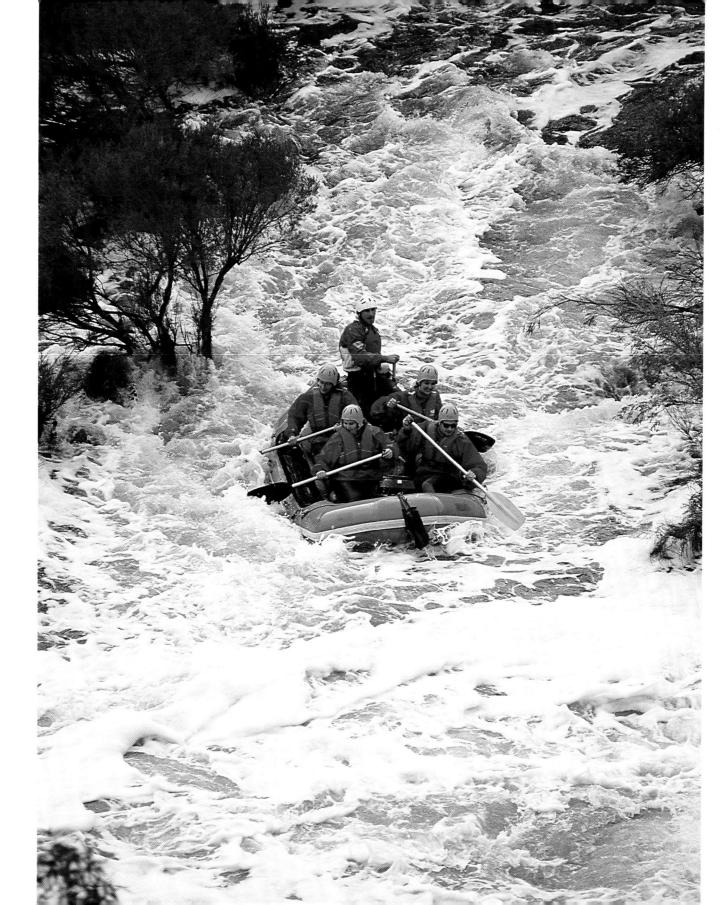

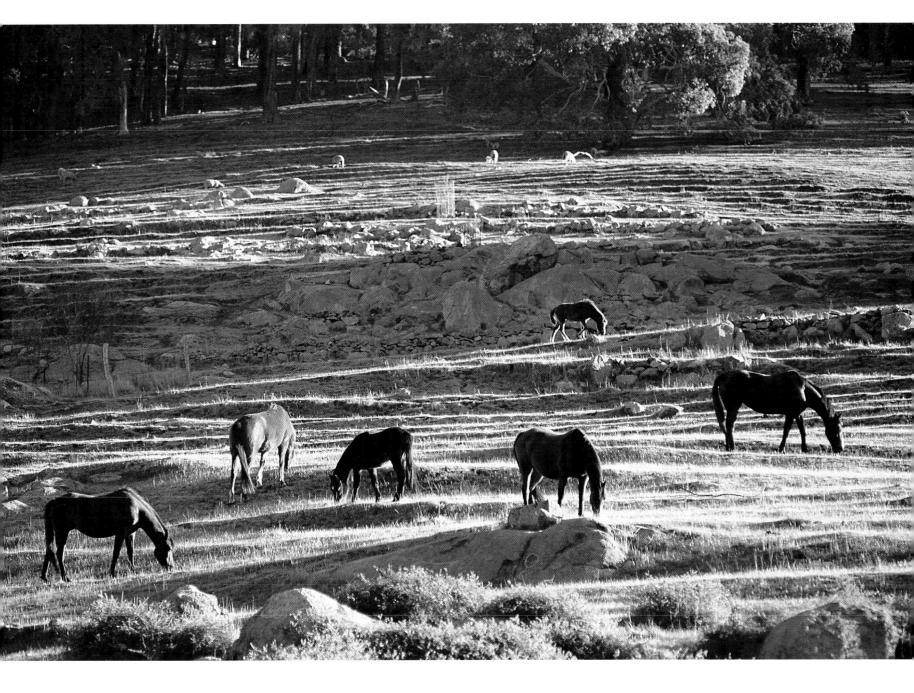

A tranquil scene — horses at pasture on an old vineyard in the hills above Perth.

White-water rafting on a turbulent Murray River.

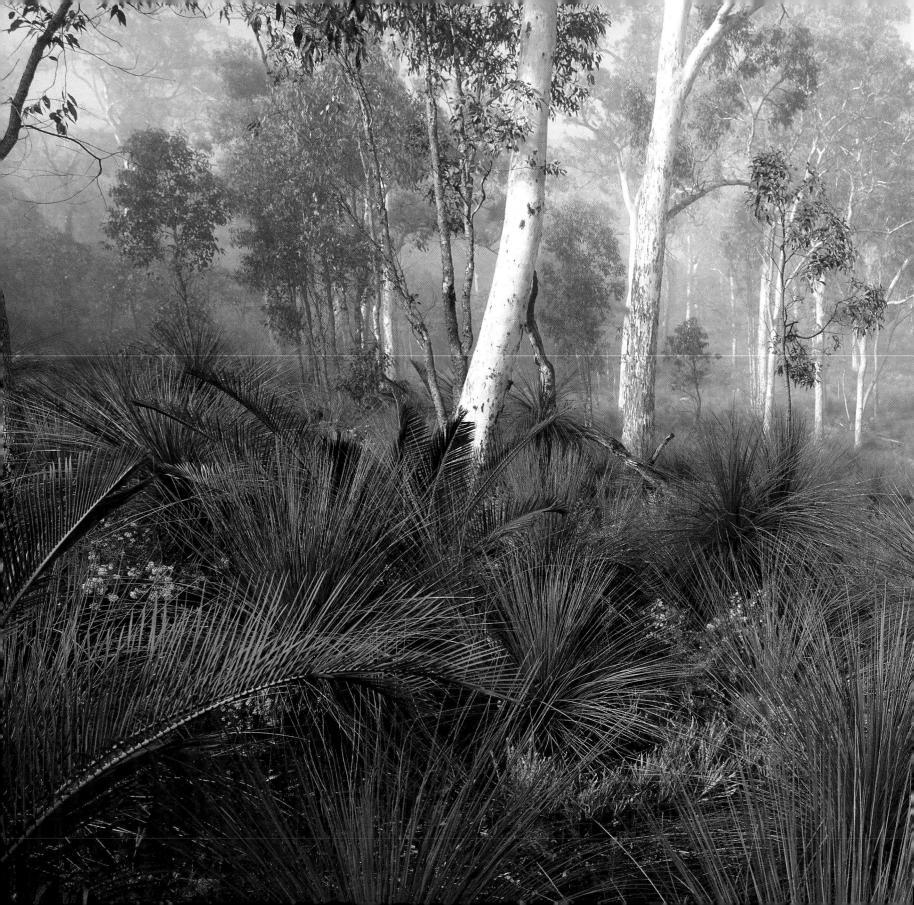

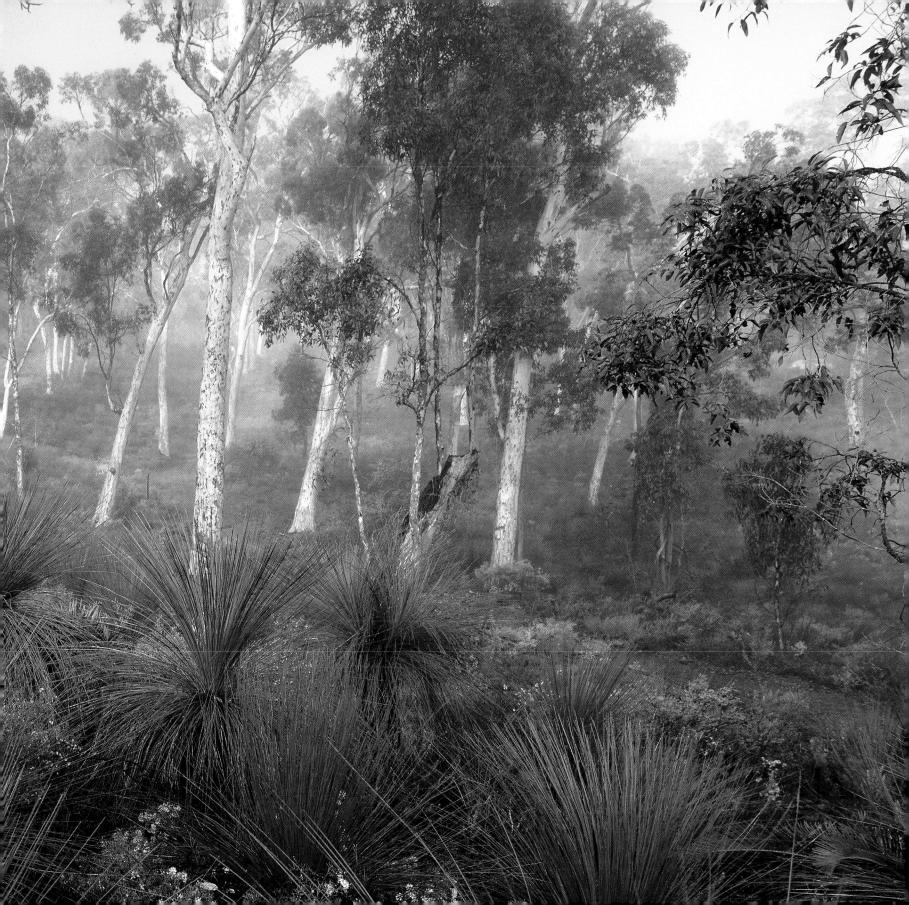

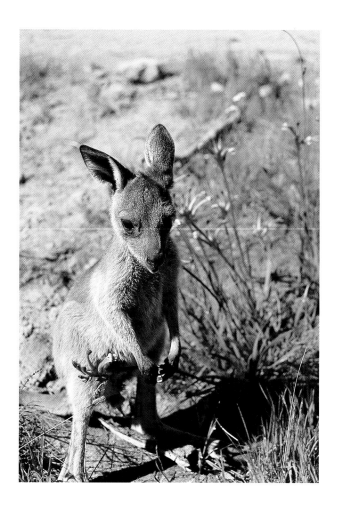 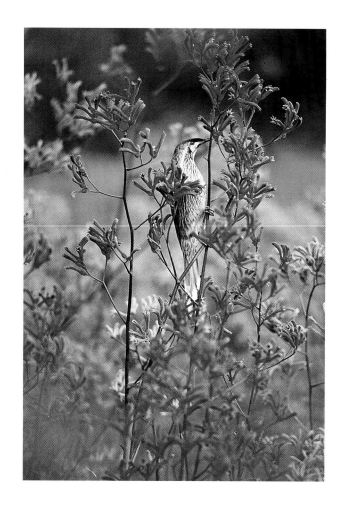

Overleaf: Pale shafts of wandoo trees, Darling Range, east of Perth.

Flora with fauna — all natives of Western Australia.

A honeyeater taps the honeyed spike of a grasstree or blackboy.

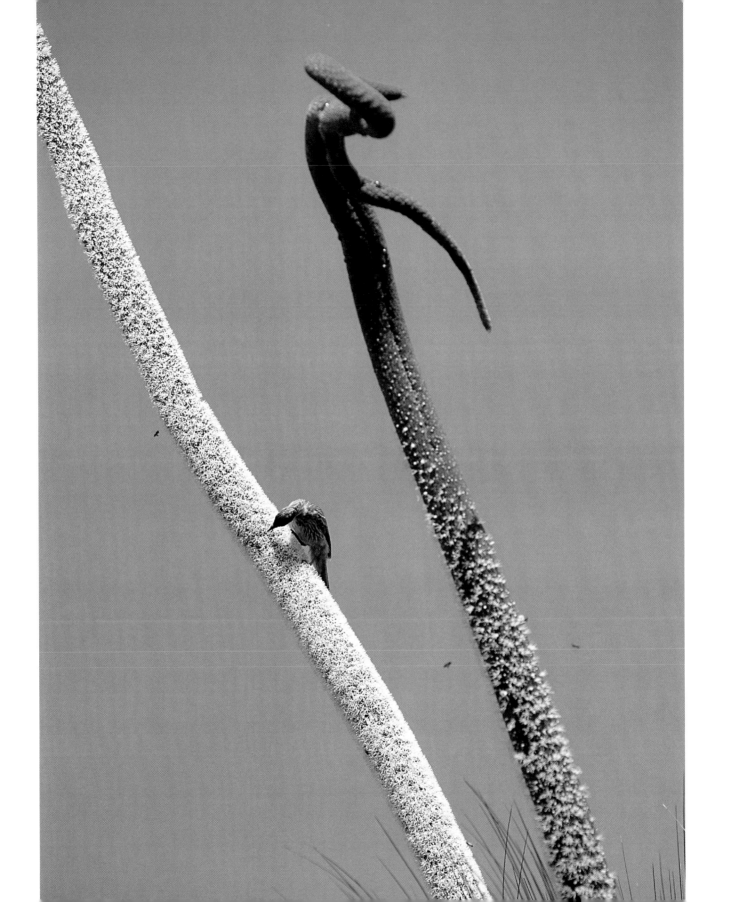

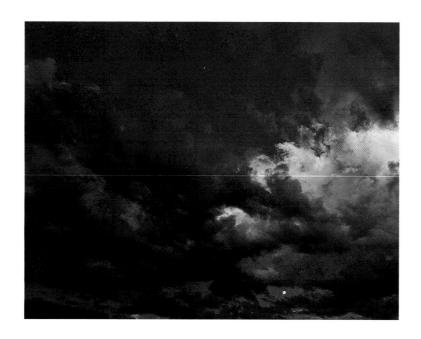

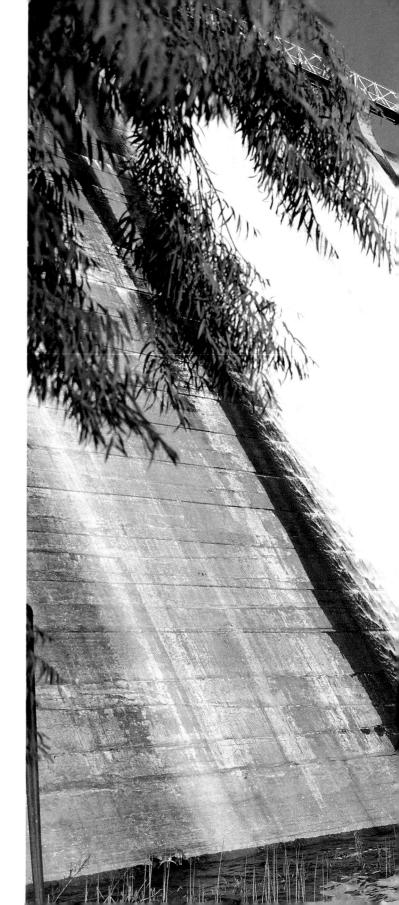

A storm brewing over the Darling Range.

Mundaring Weir in the Darling Range was built in 1902 by
engineer C Y O'Connor to supply water to the dusty Kalgoorlie
Goldfields, over 500 kilometres to the east.

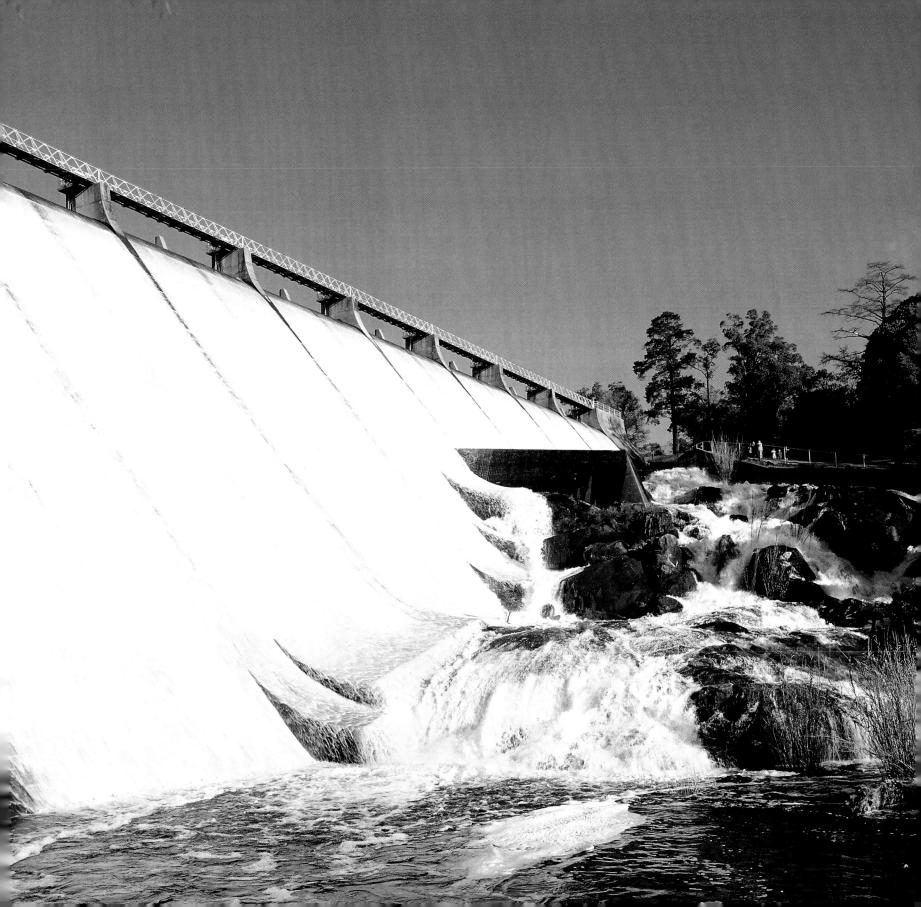

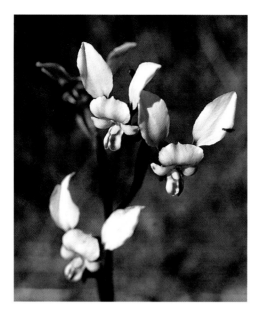

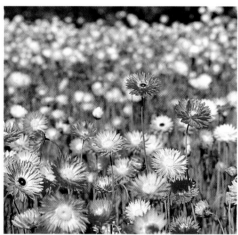

Australia's west is known for the stunning variety and unique nature of its wildflowers.

The bright faces of donkey orchids.

A papery profusion of everlastings.

Clumps of the brilliant verticordia known as 'Morrison', with Australia's version of the Christmas tree (*Nuytsia floribunda*) in the background.

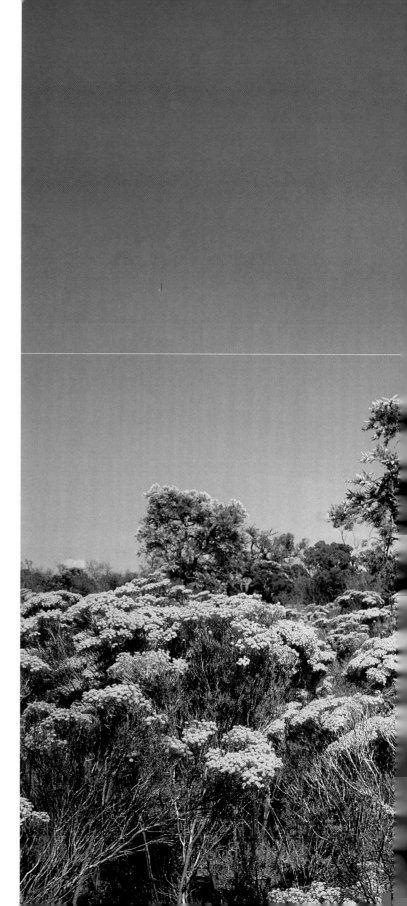

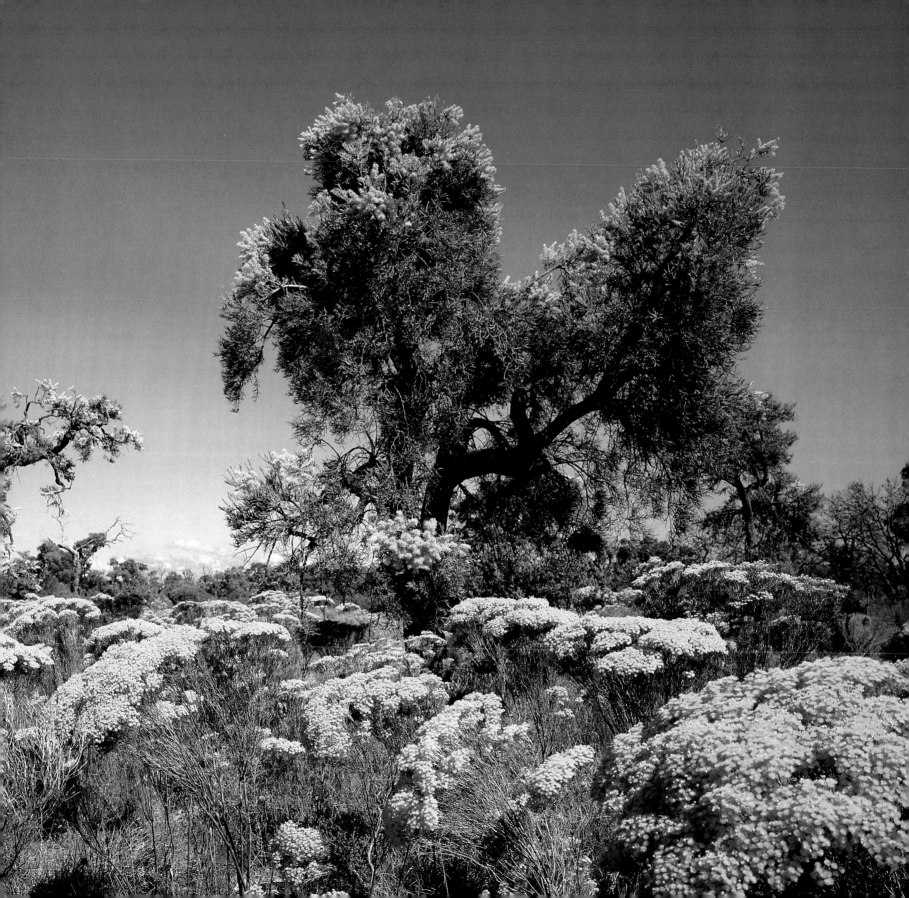

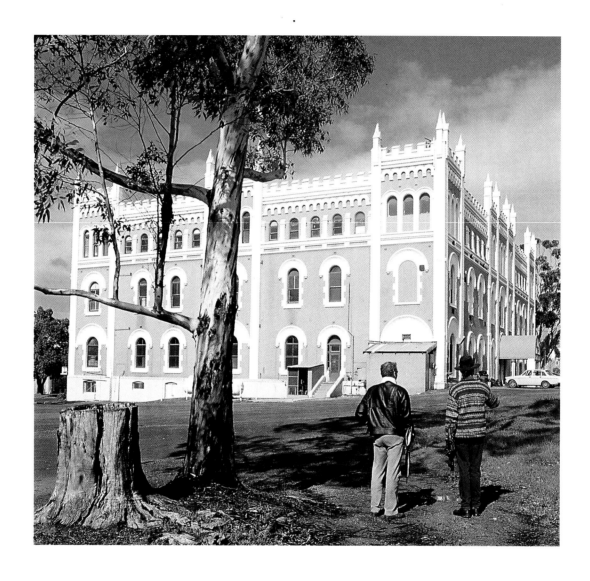

Western Australia is not without its links to Europe. New Norcia, a monastery town 132 kilometres north of Perth, was built by the monks of the Spanish Benedictine Order in 1846.

St Gertrude's Chapel, New Norcia.

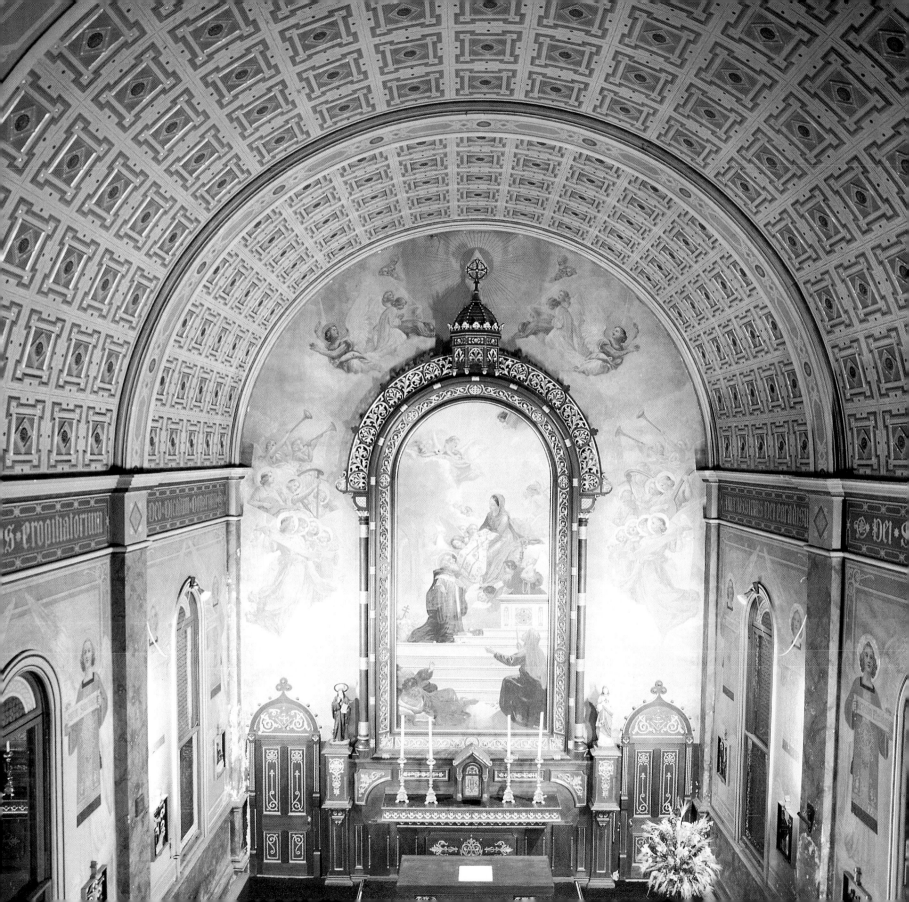

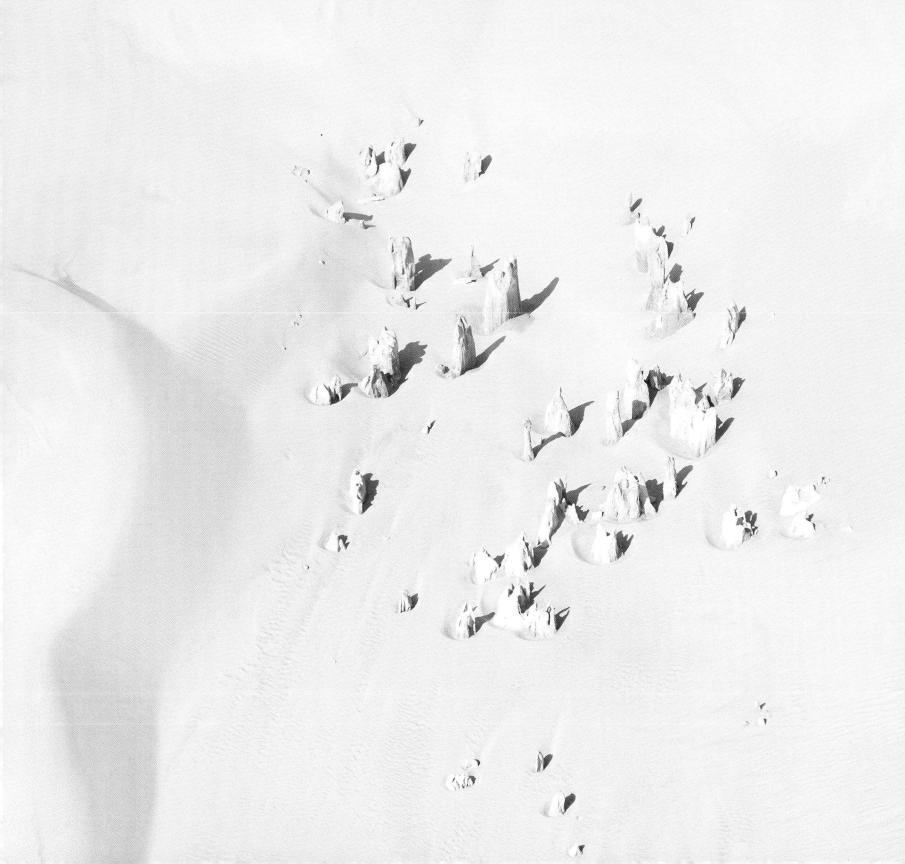

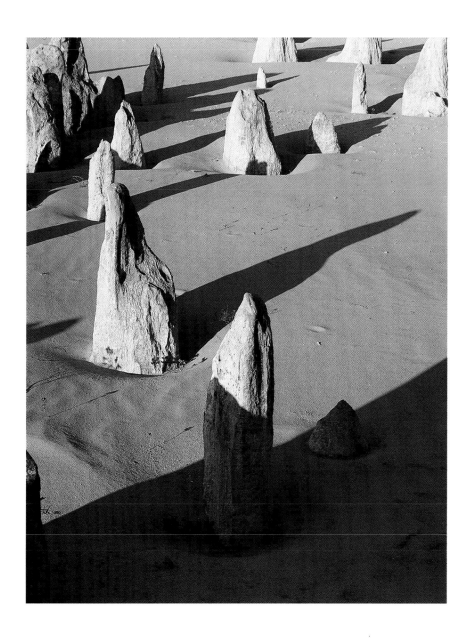

The Pinnacles — a fascinating moonscape on the coast north of Perth.
Thousands of limestone shapes have been formed by the leaching of minerals
into mounds left behind by the trunks of a long-vanished forest.

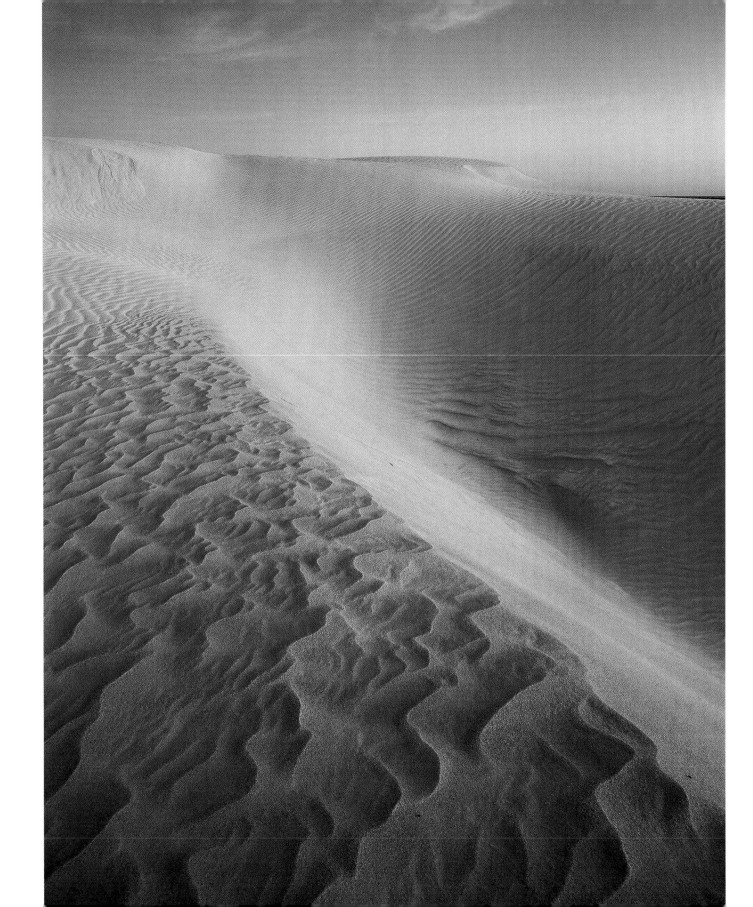

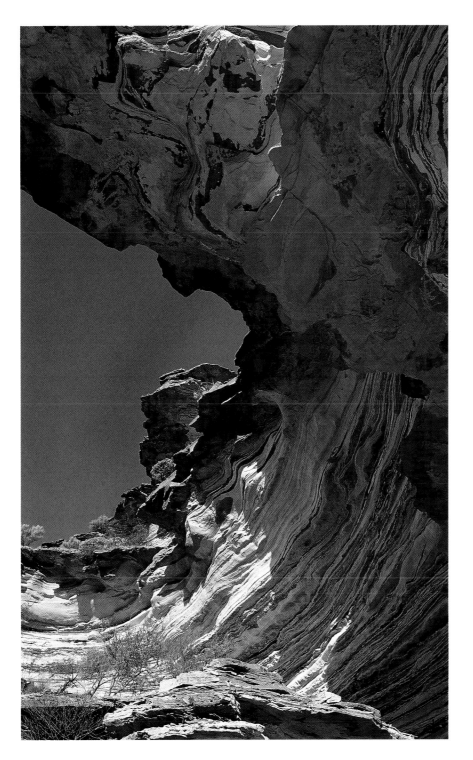

The 12,000 kilometre stretch of Western Australia's coastline displays enormous variety and great beauty.

Shifting sand dunes near Lancelin.

The strangely striped sandstone cliff of a gorge along the Murchison River. At the river mouth is Kalbarri, a popular fishing and holiday town.

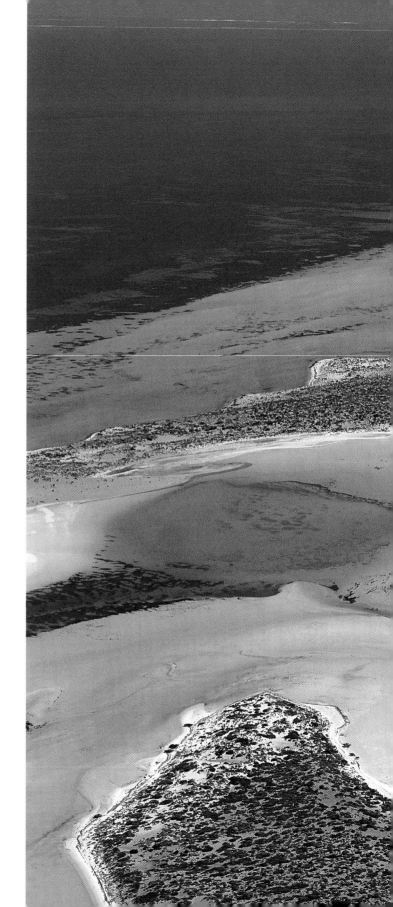

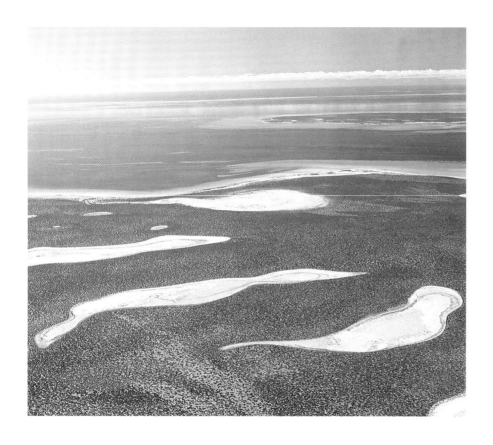

Shark Bay, now on the world's heritage list, has a wide diversity of
flora and fauna.

The 'birridah' (an Aboriginal word meaning 'footsteps of the
giant') are small salt lakes on the Peron Peninsular.

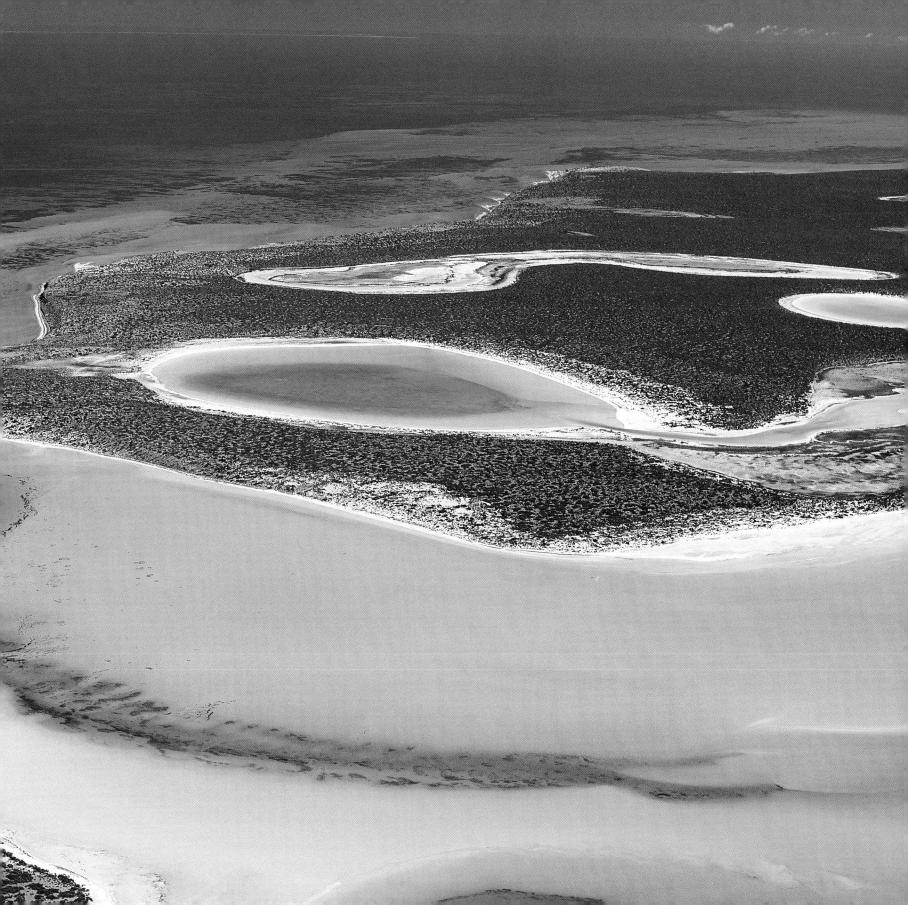

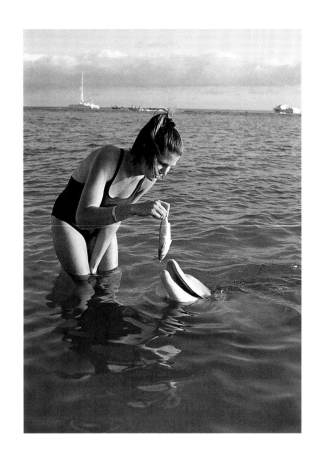

Unafraid, curious and friendly, the dolphins of
Monkey Mia freely interact with their human visitors.

The haunt of the dolphins, seen from the air,
Monkey Mia, Shark Bay.

Overleaf: Sandstone cliff on the Murchison River,
Kalbarri National Park.

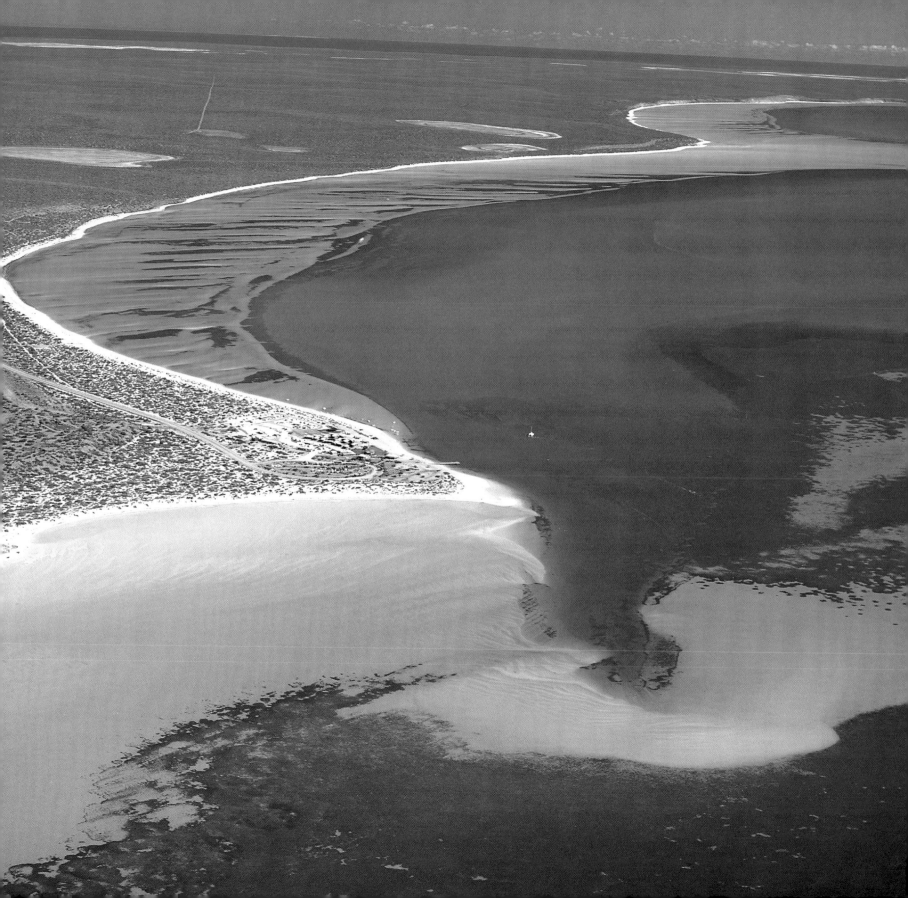

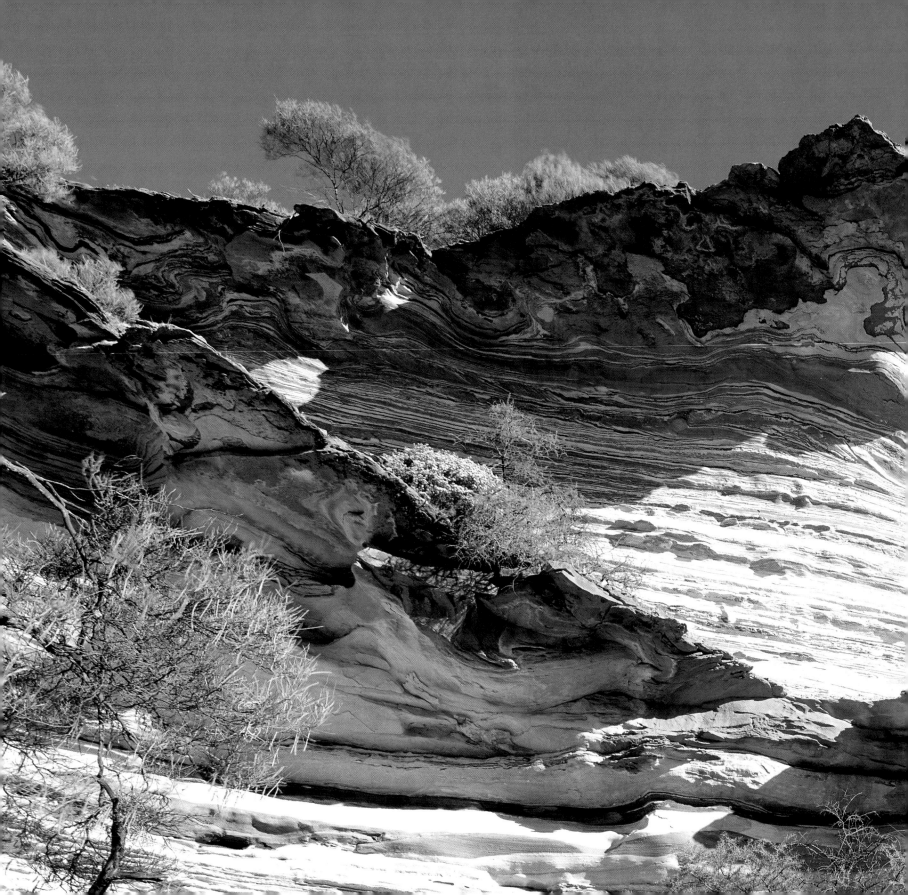

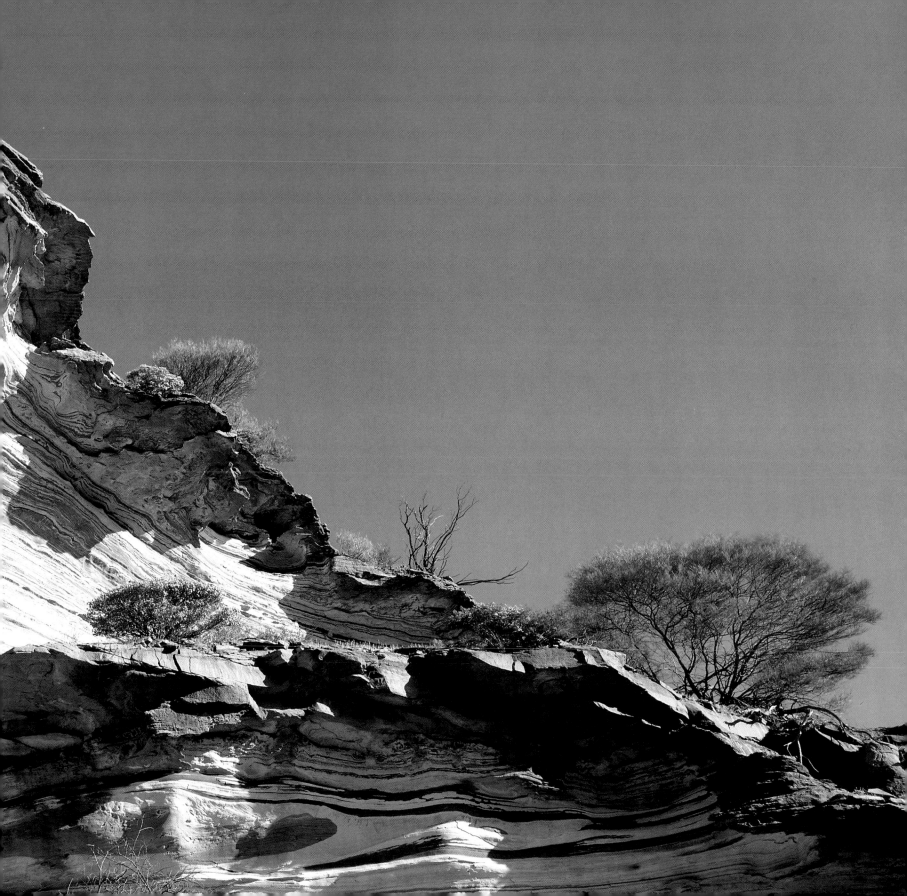

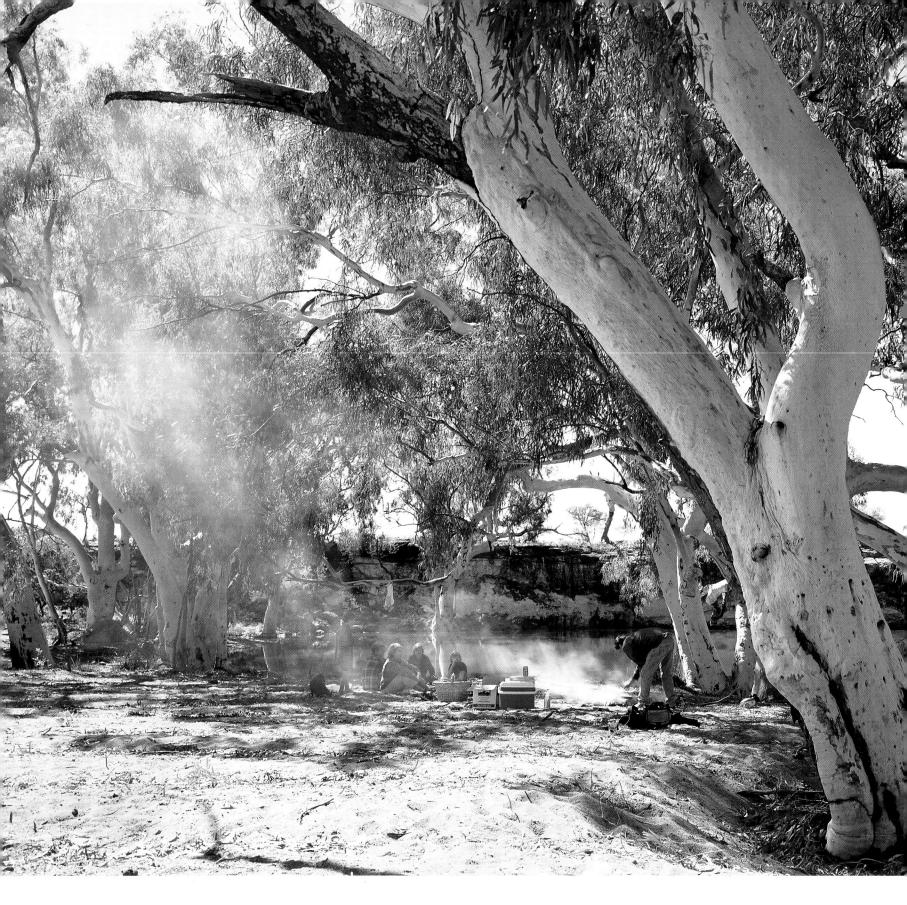

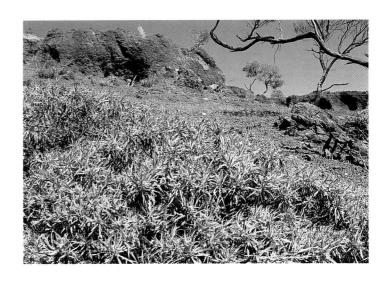

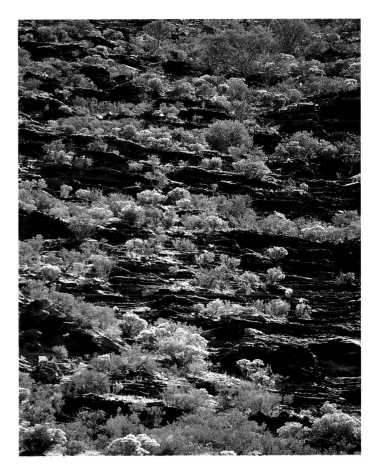

Picnic by a billabong on a Murchison sheep station.

Each year in August-September the scrub erupts into flower. The abundance of the display depends on the amount of rain that has fallen during the early winter months.

Overleaf: A billabong on Byro Station in the Murchison.

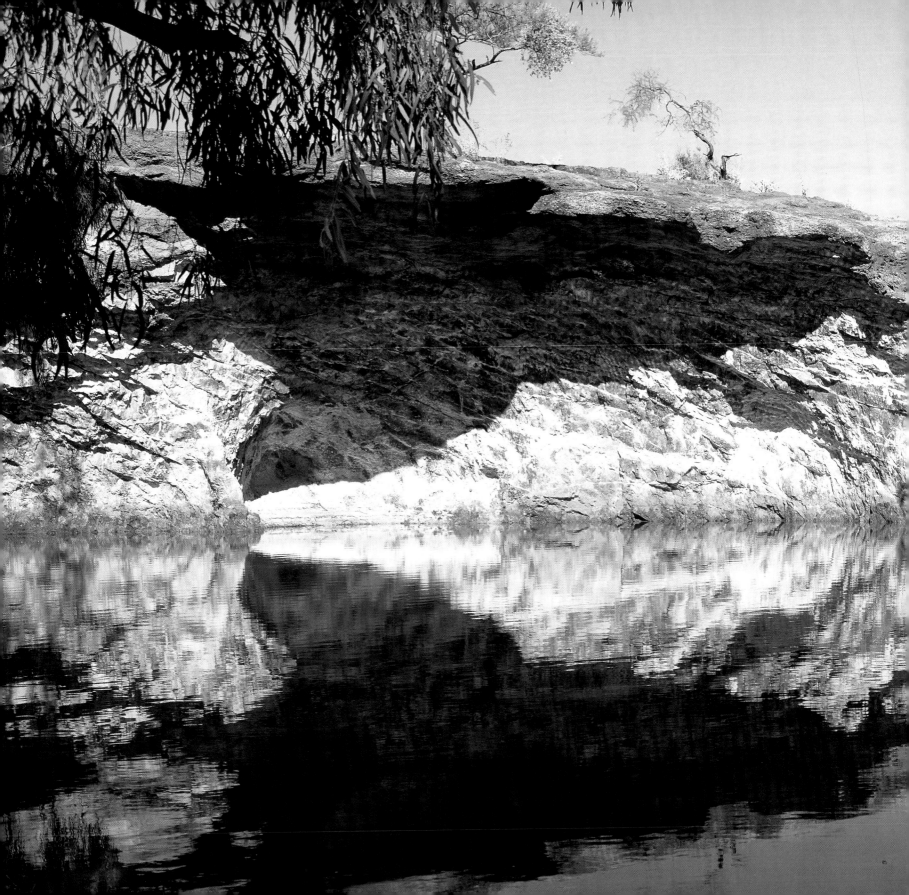

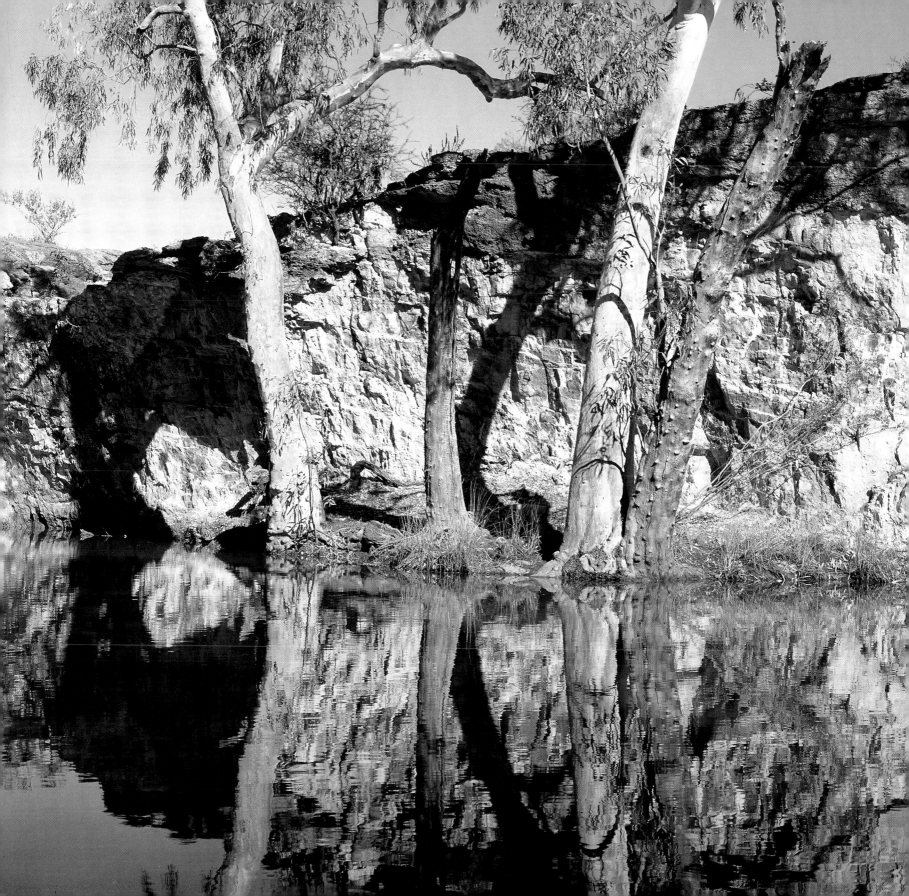

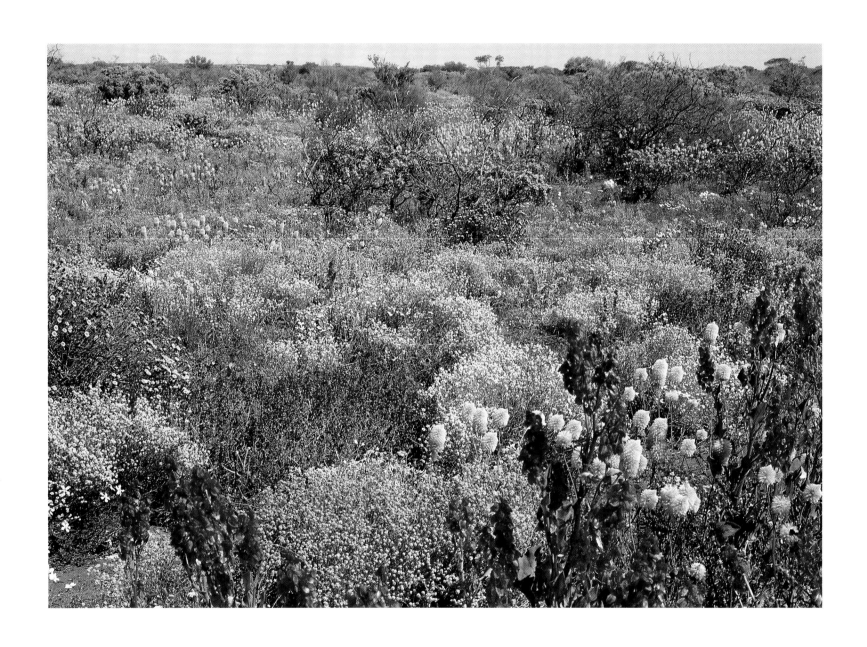

After the rains a flowery carpet softens and colours the harsh, bare soil of the Murchison.

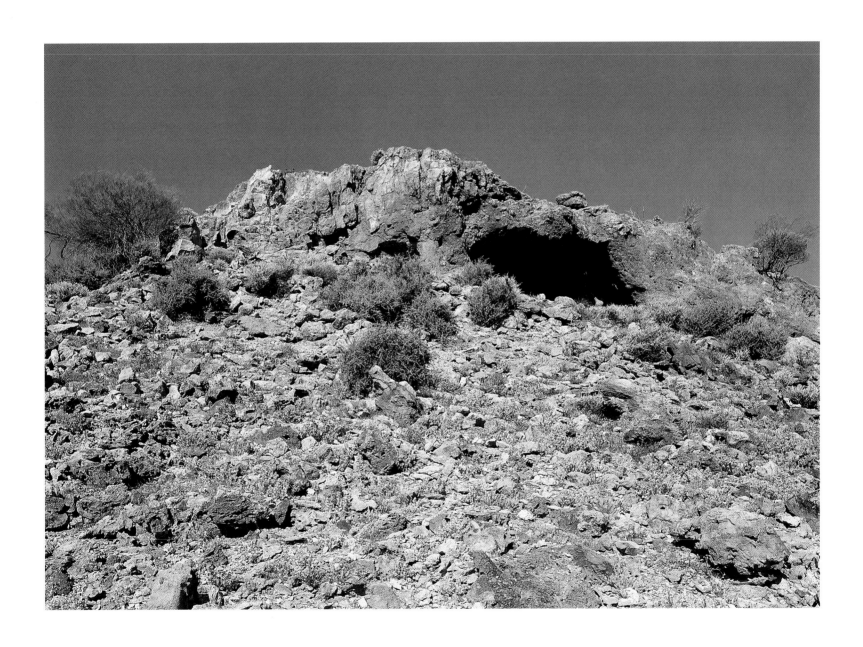

Overleaf: The pastel colours of everlastings clothe the red earth each spring, from Geraldton to Paynes Find and beyond.

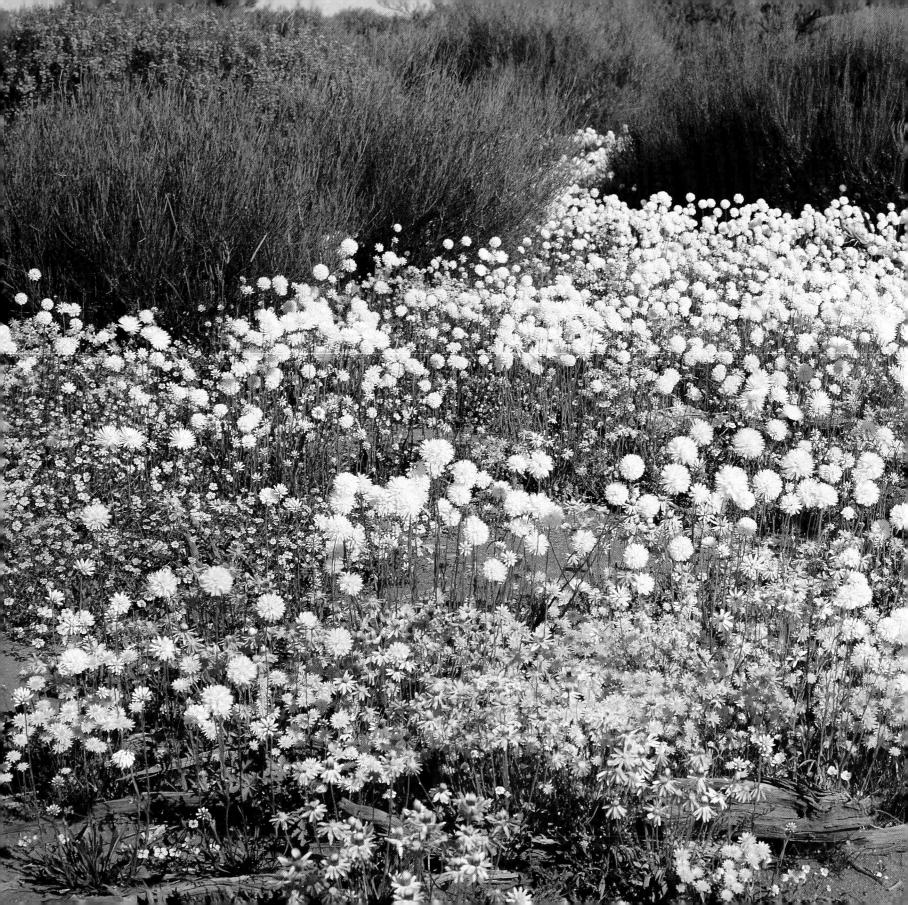

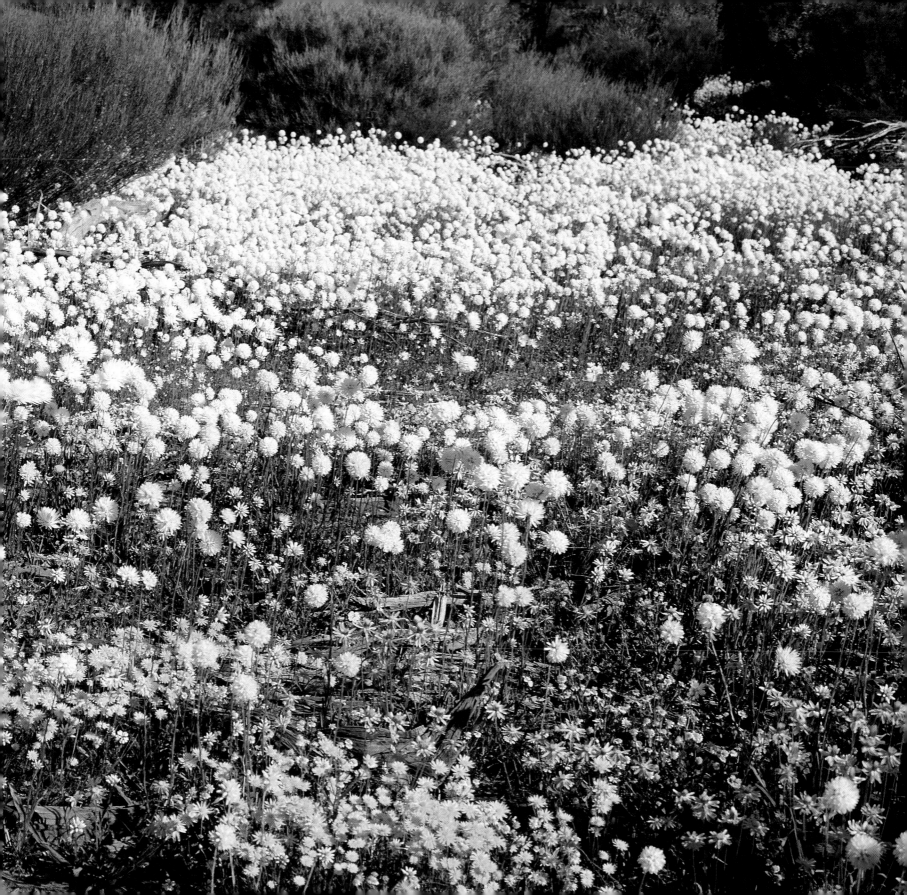

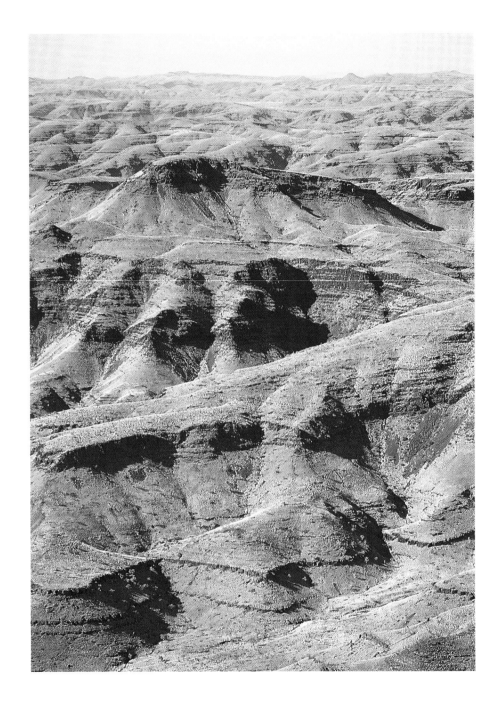

Clad in spinifex grass, the Hamersley Ranges run through the Pilbara. A delicate haze of green after rain, the landscape dries out to yellow during the long dry summer.

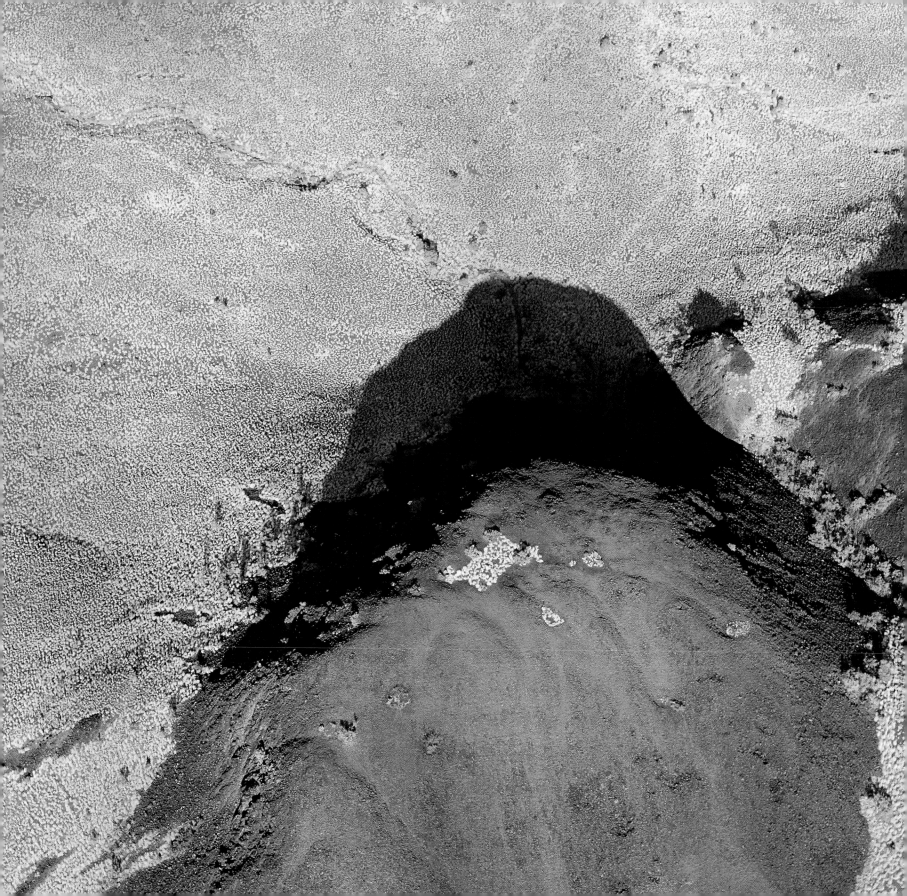

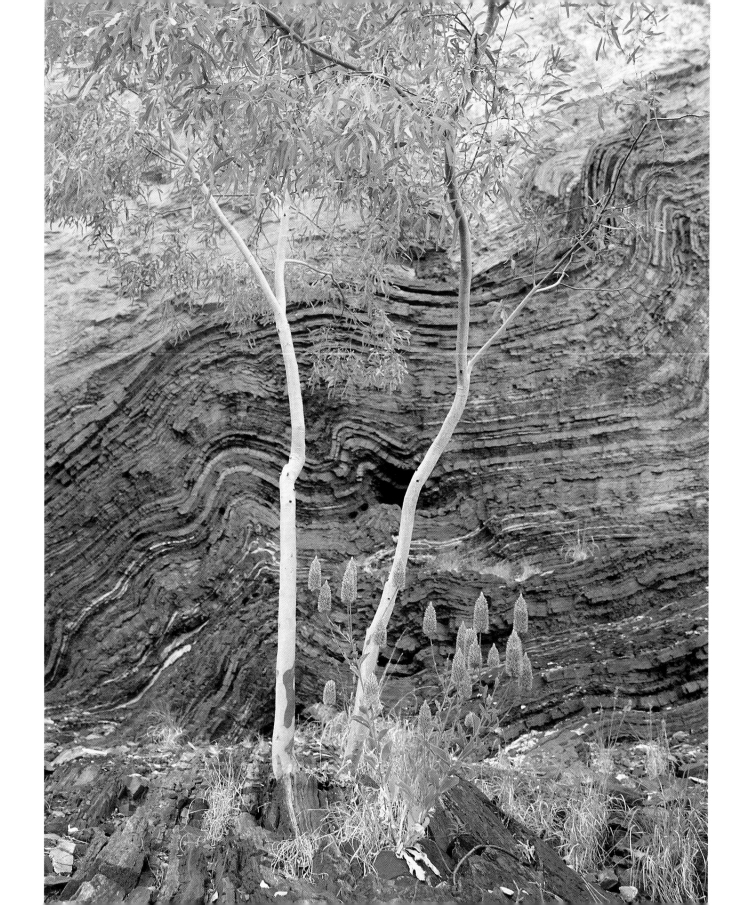

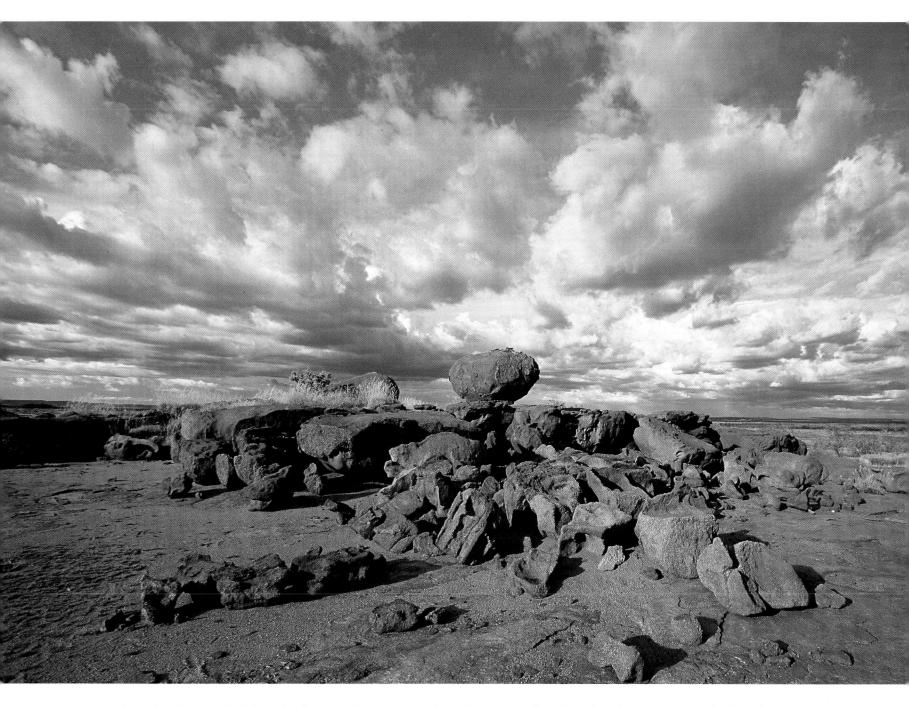

Hamersley Gorge in the Hamersley Ranges. The intricate geological patternings have been forged in some primeval upheaval.

A jumble of rocks created by aeons of weathering, seen under the wet season's clouded skies.

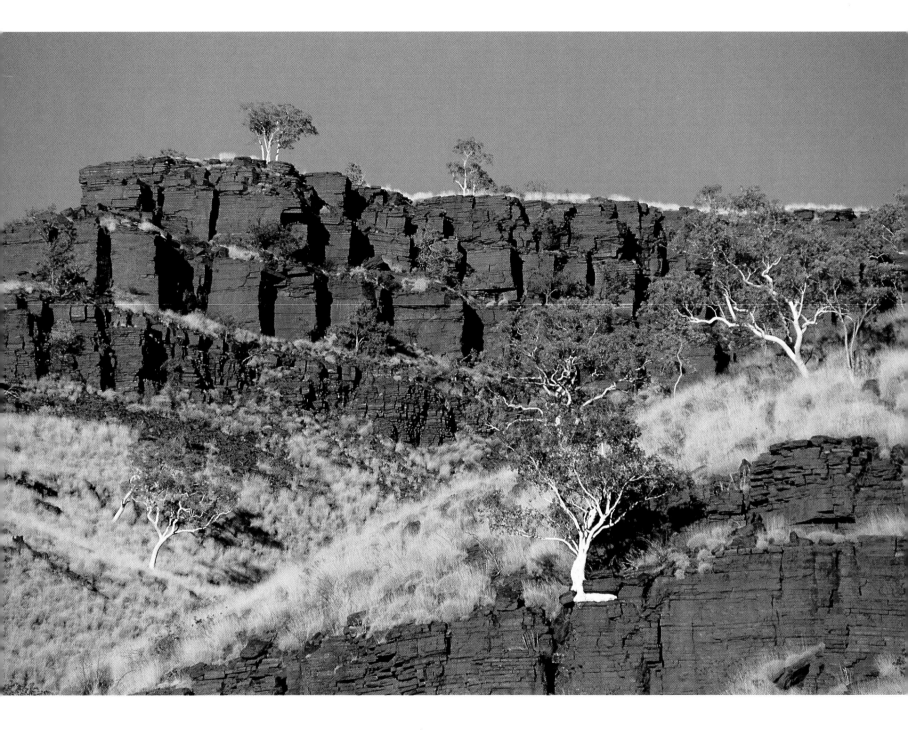

Wittenoom and Hancock Gorges in the Pilbara.

The gorges have been formed by wind and water erosion over millions of years.

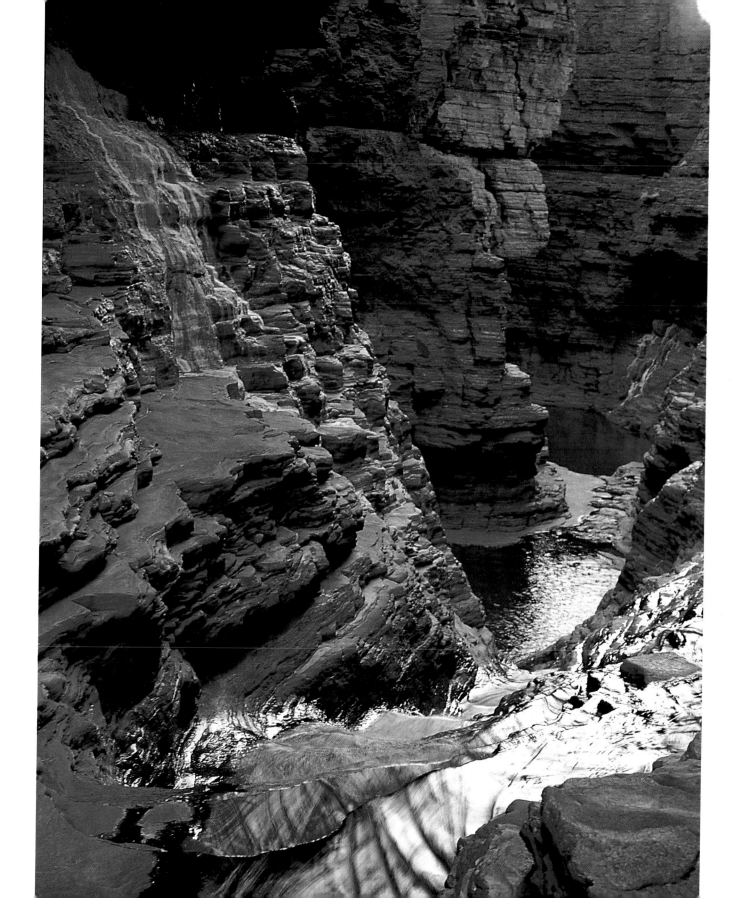

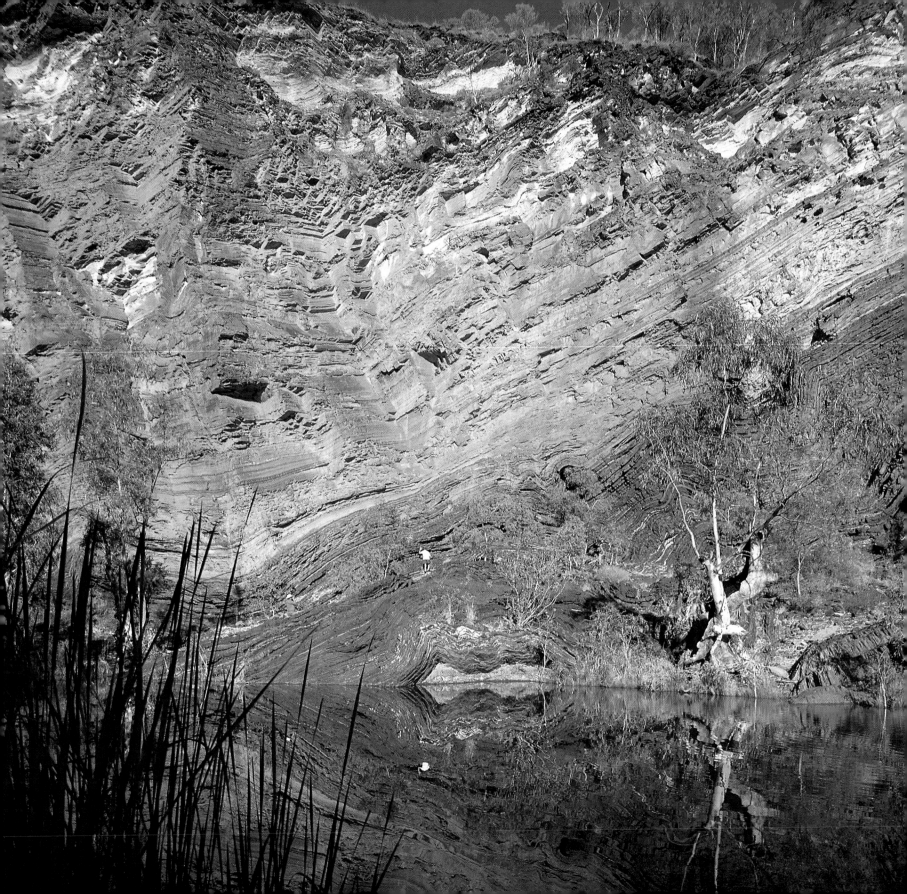

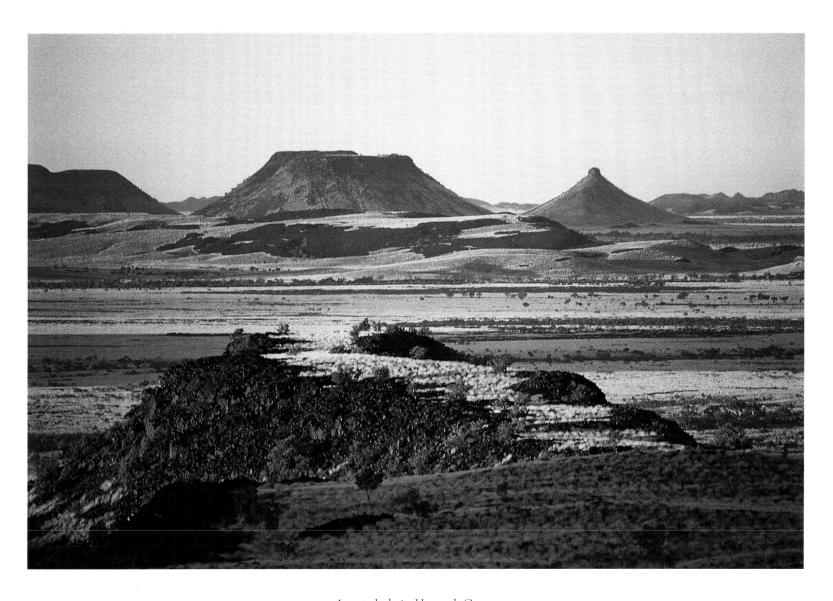

A waterhole in Hancock Gorge.

View from Mount Herbert towards Pyramid Hill in the Chichester Range.

Overleaf: The drama of boulders stained by sunset light, along the road between Newman and Port Hedland.

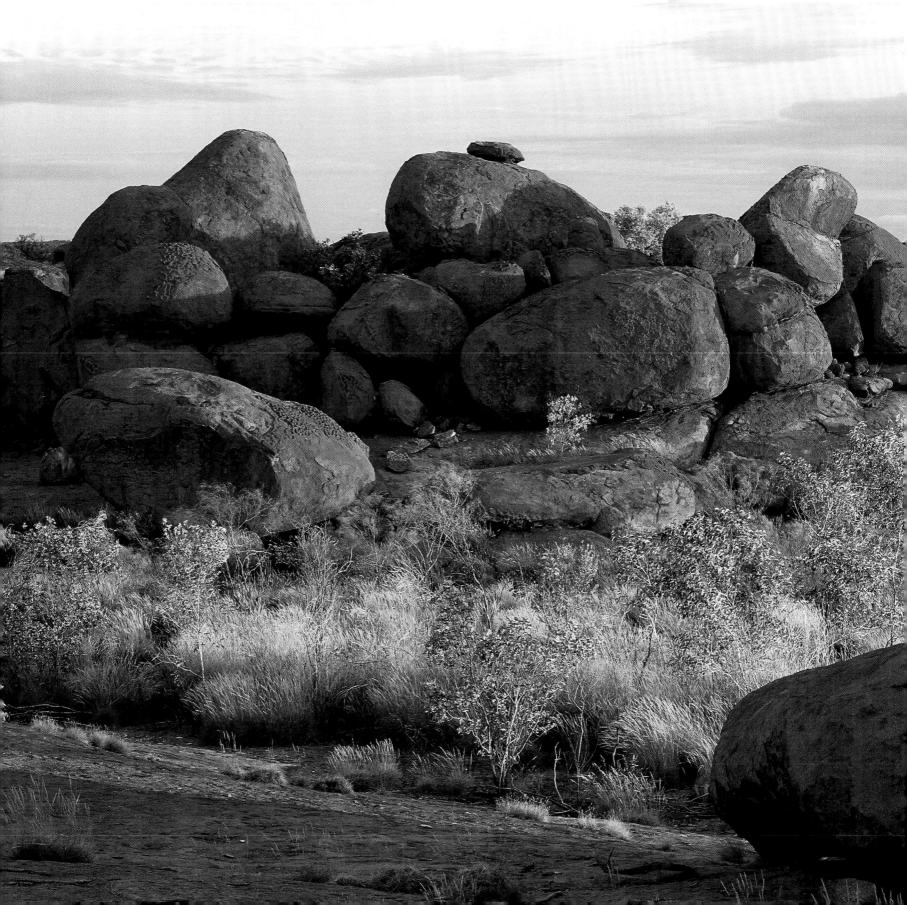

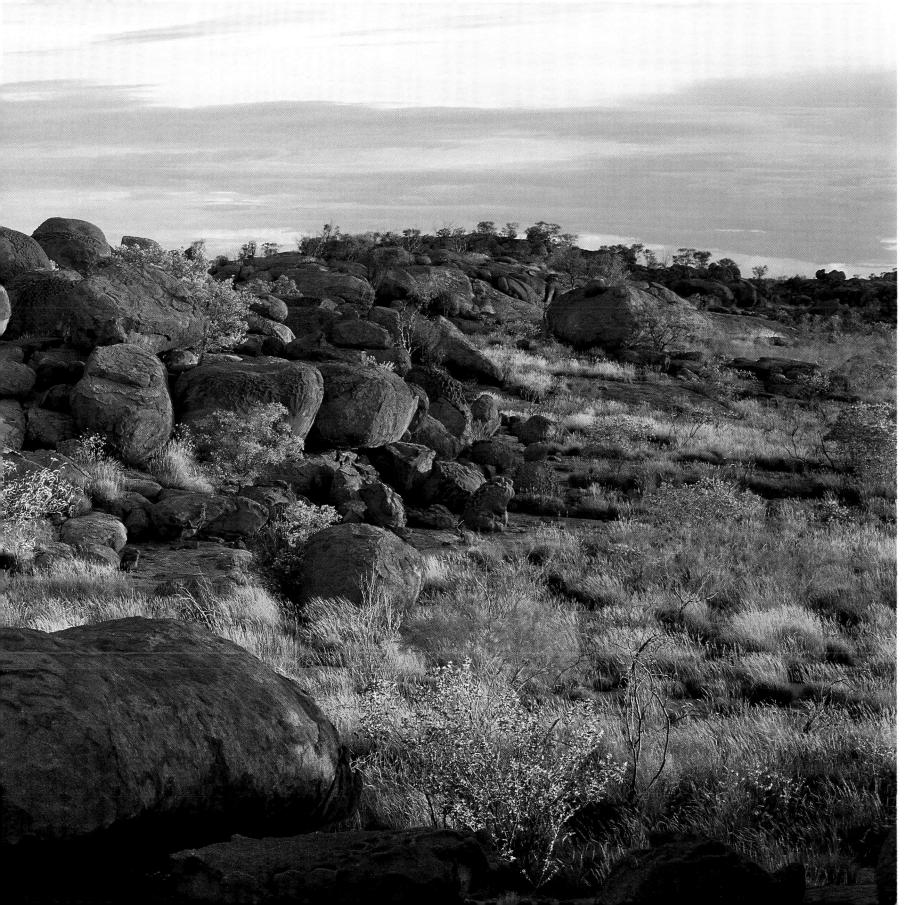

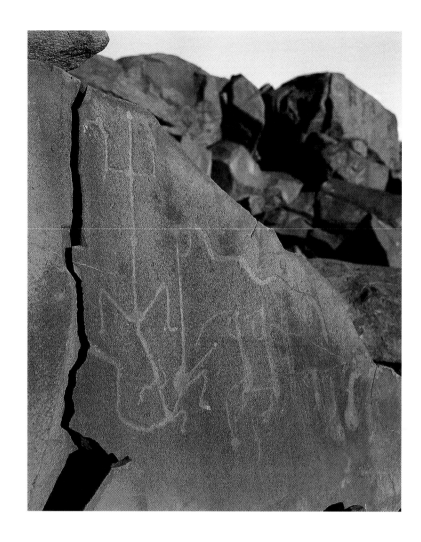

The hand of man has been here too: Aboriginal rock carvings,
Burrup Peninsula.

The stunning sweep of the Pilbara landscape. Not only rich in
minerals, this area also supports many cattle and sheep stations.

Overleaf: Lake Argyle at sunset.

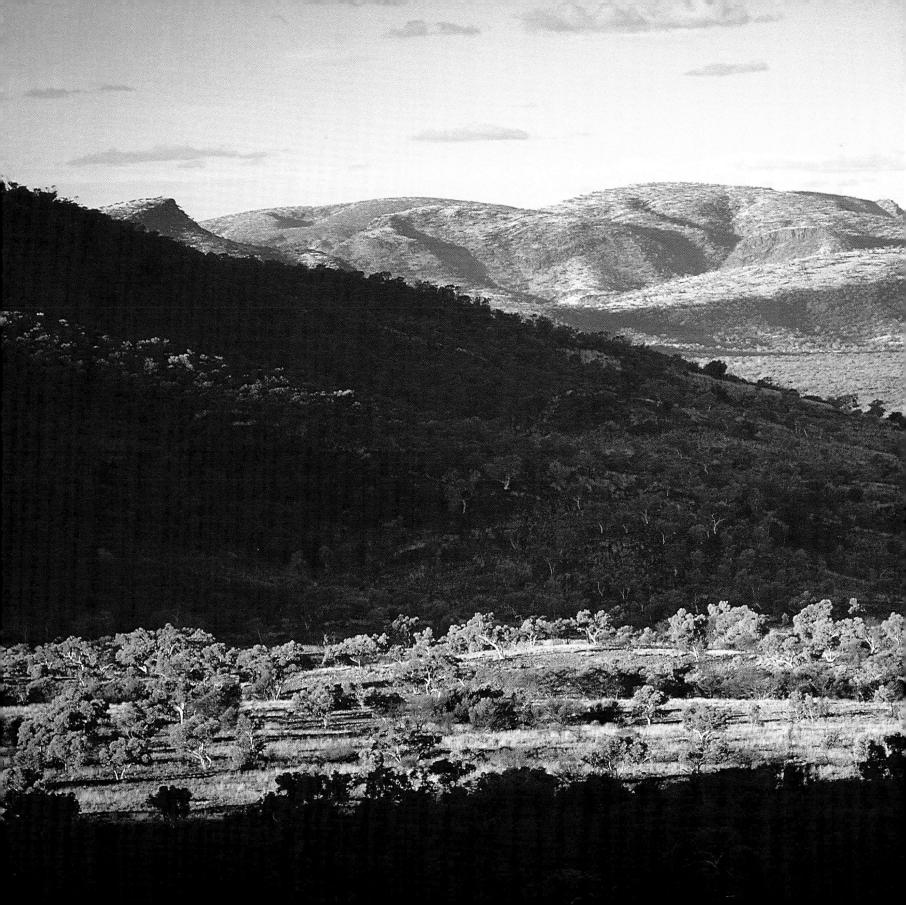

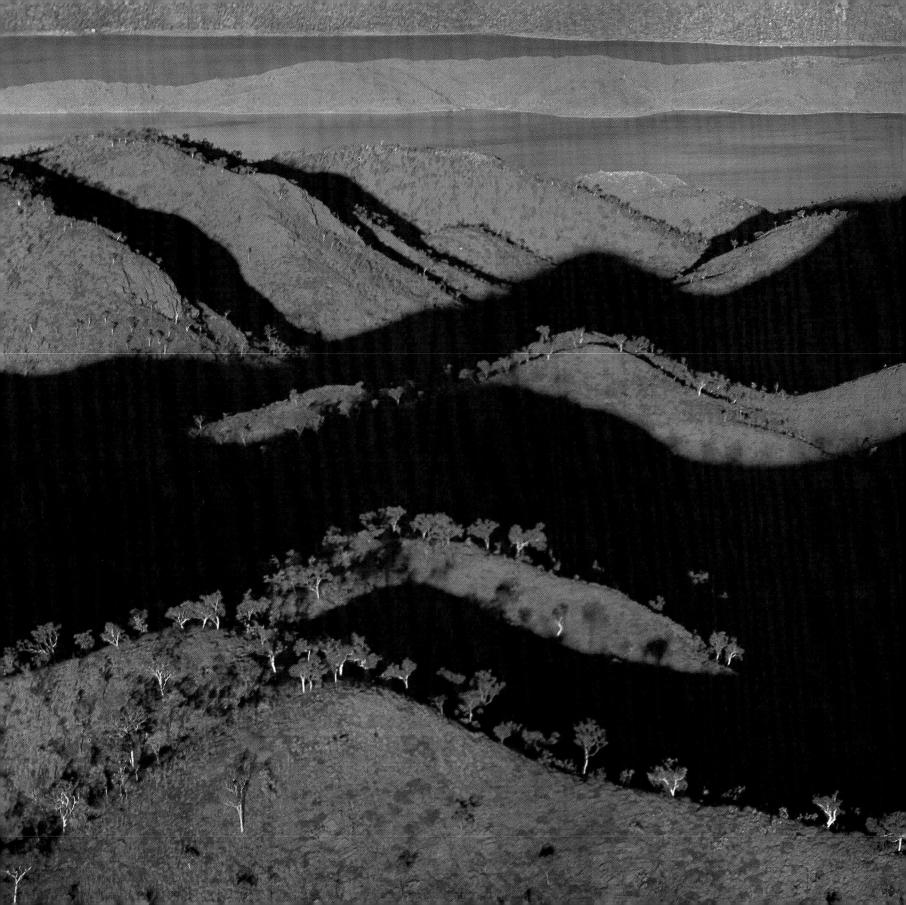

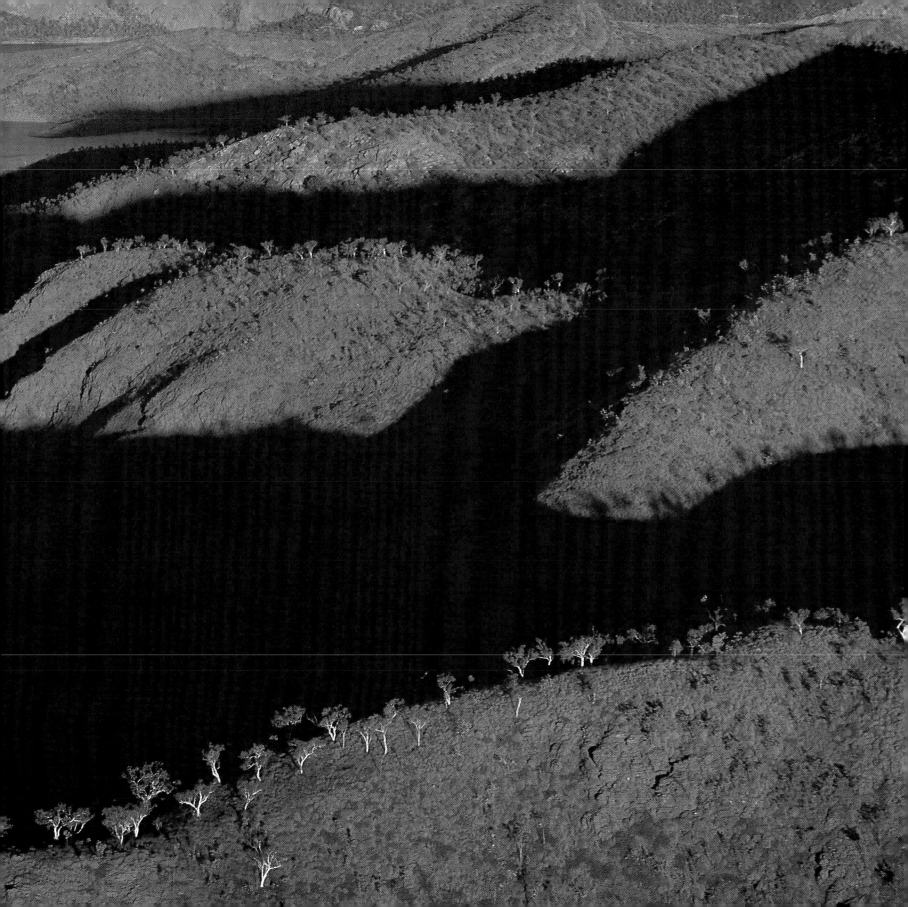

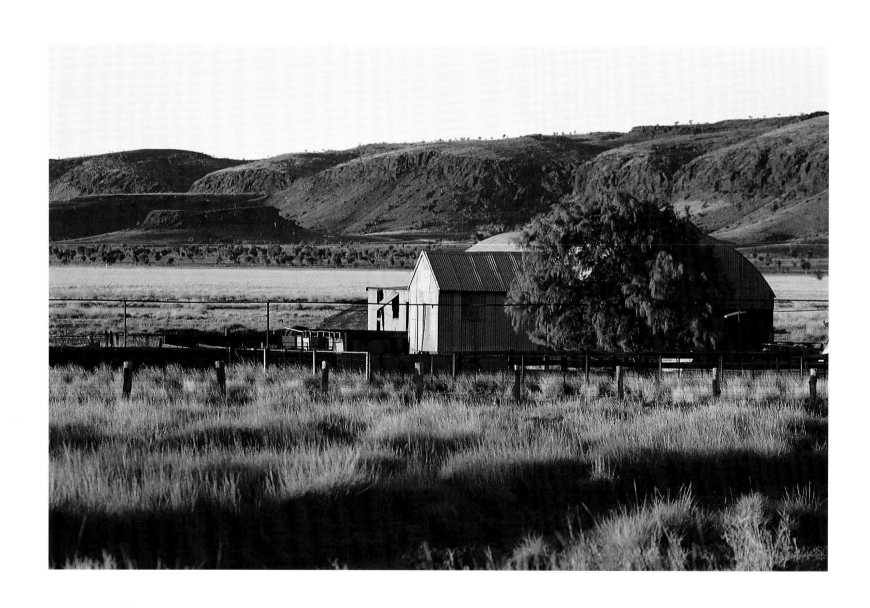

A relic of the pioneer past, an old shearing shed is a reminder of the days when wool growing was a major industry in the Pilbara.

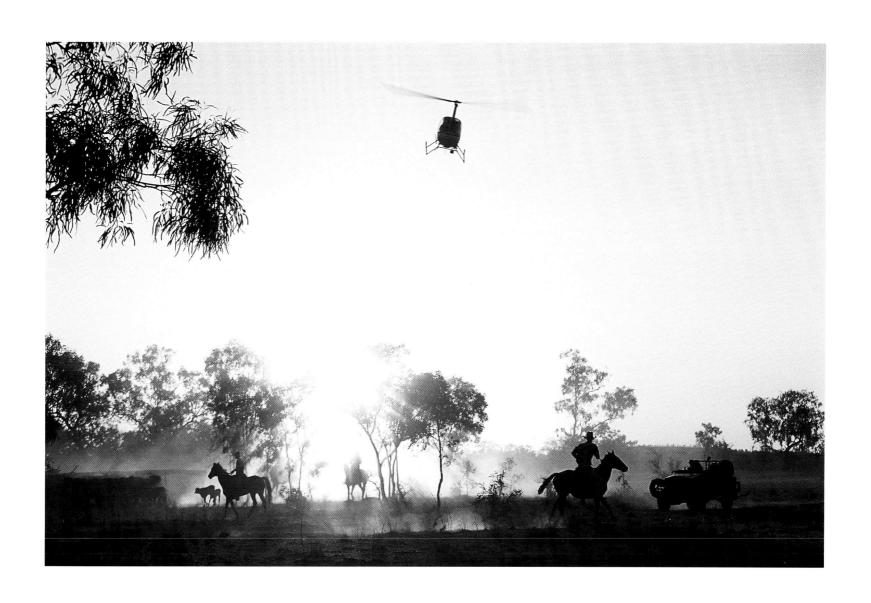

Now it is cattle which dominate the scene on the stations of the north.

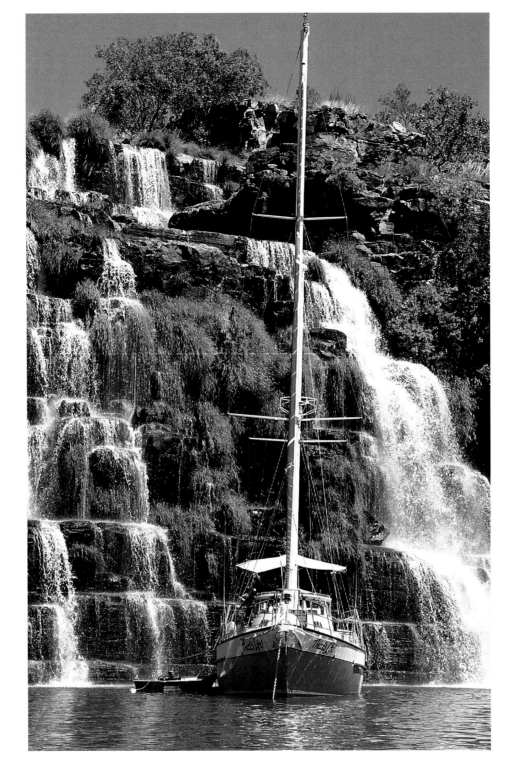

Water is the life blood of this land. King Cascade and a waterfall, Mitchell Plateau.

Overleaf: Cable Beach, Broome.

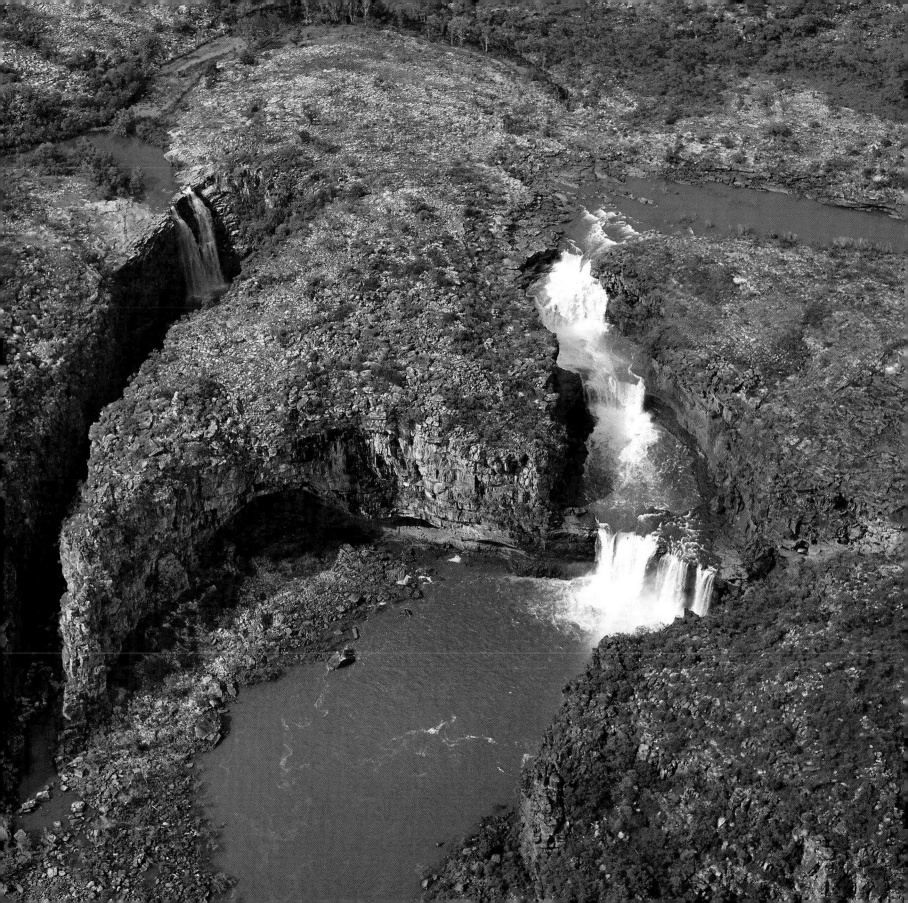

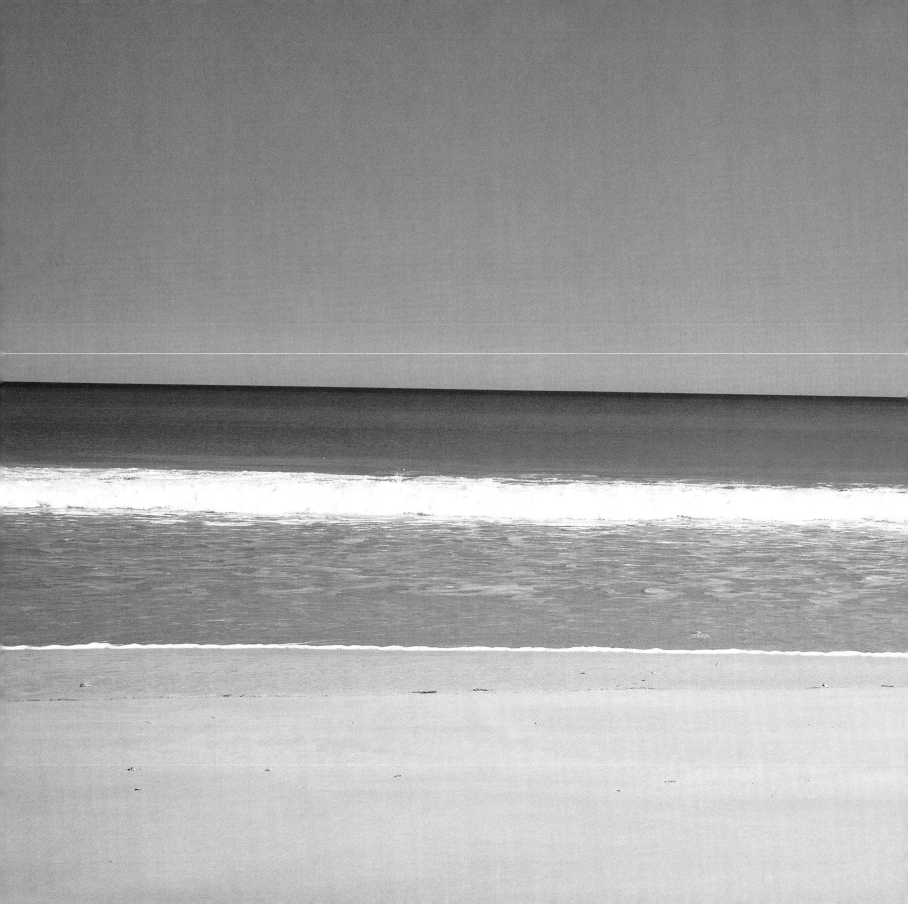

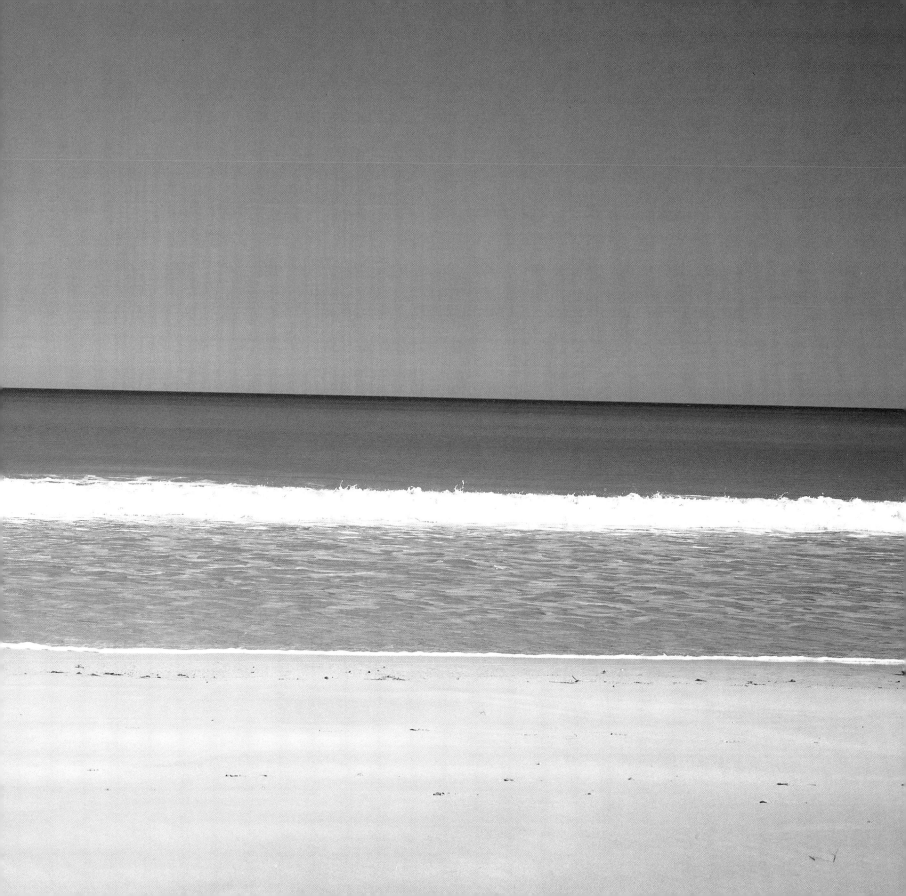

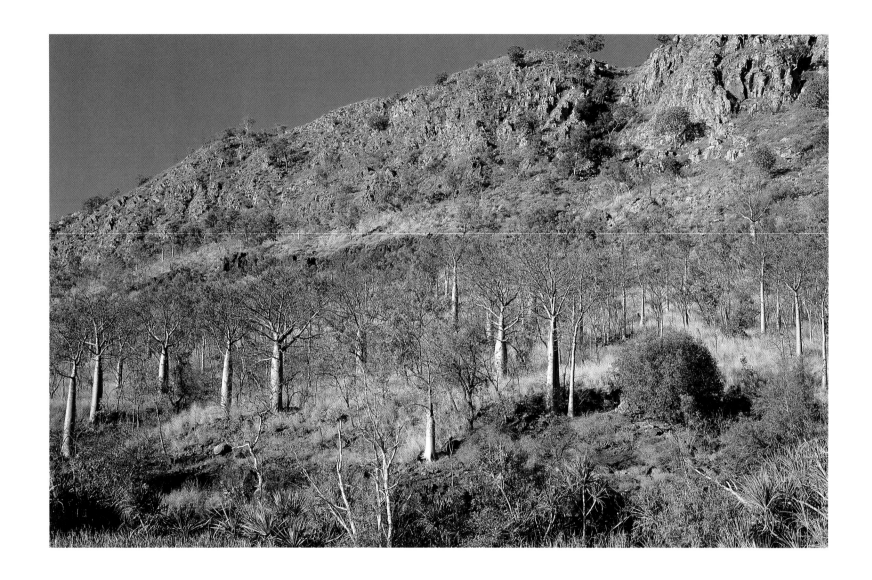

The bizarre, bottle-shaped boab tree is seen all over the north, or the 'top end' of Western Australia.

Carr Boyd Range.

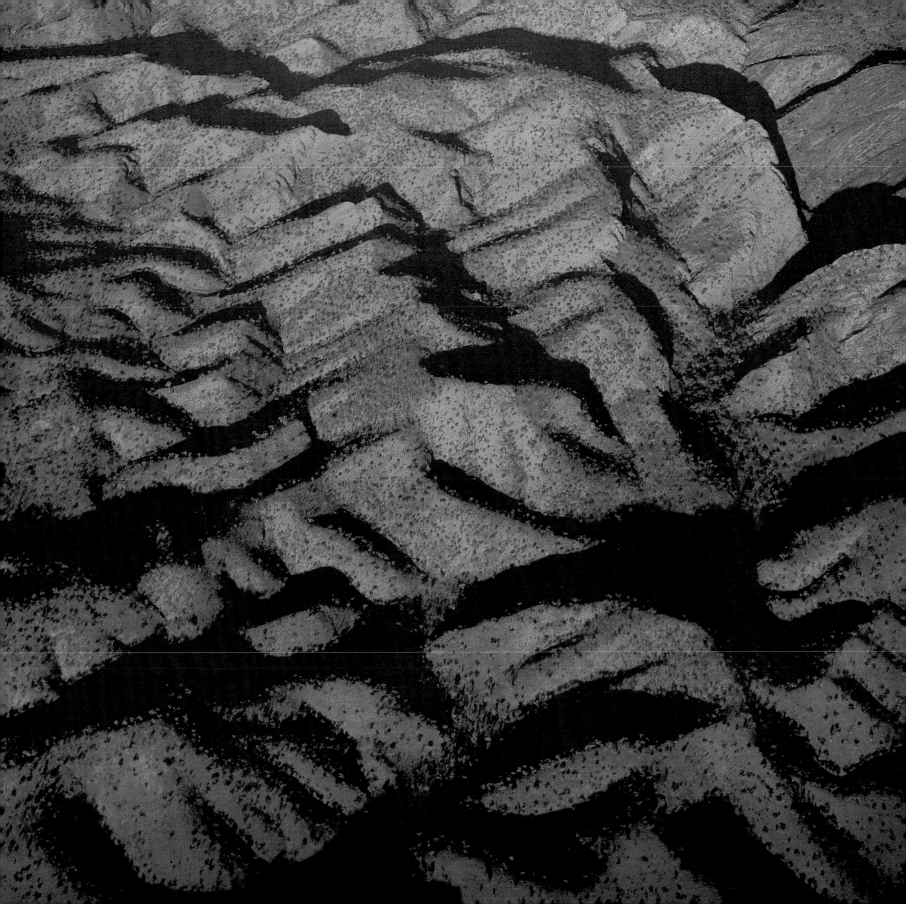

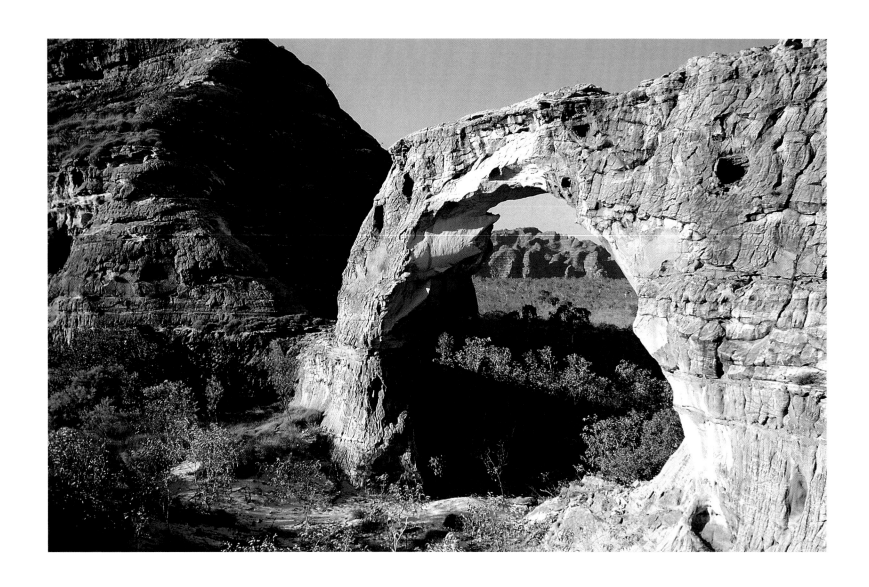

An archway in the Bungle Bungle, Purnululu National Park.

An overview of the beehive-shaped clusters of the Bungle Bungle, Purnululu National Park.

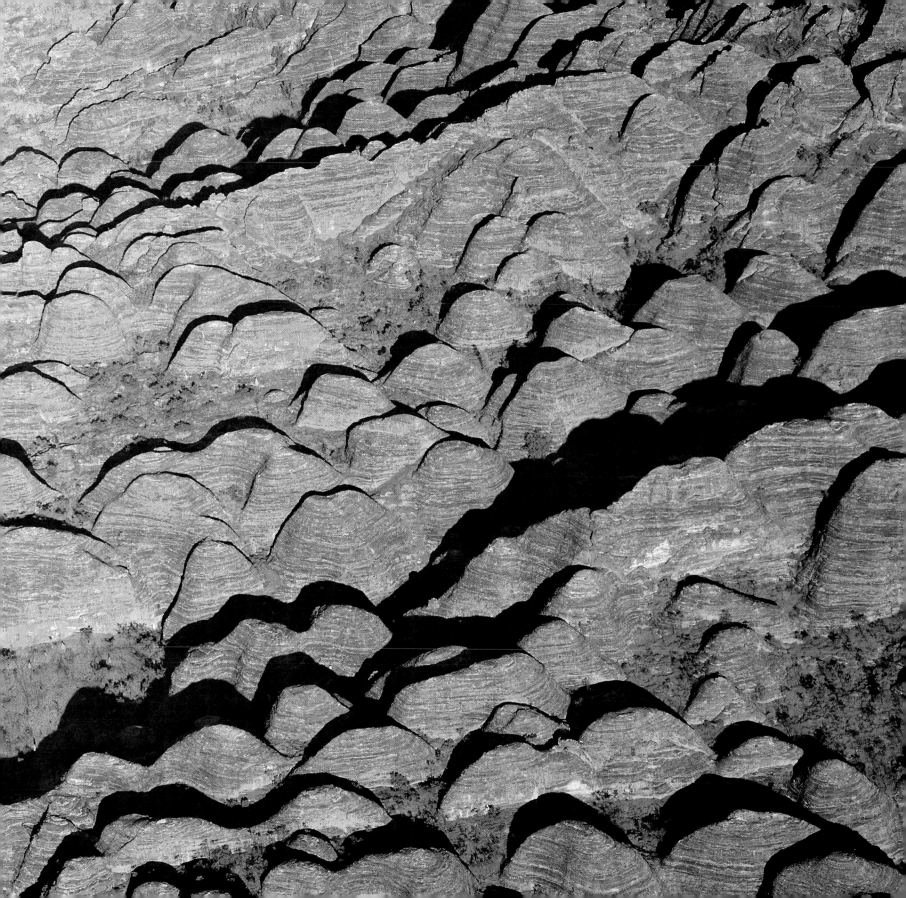

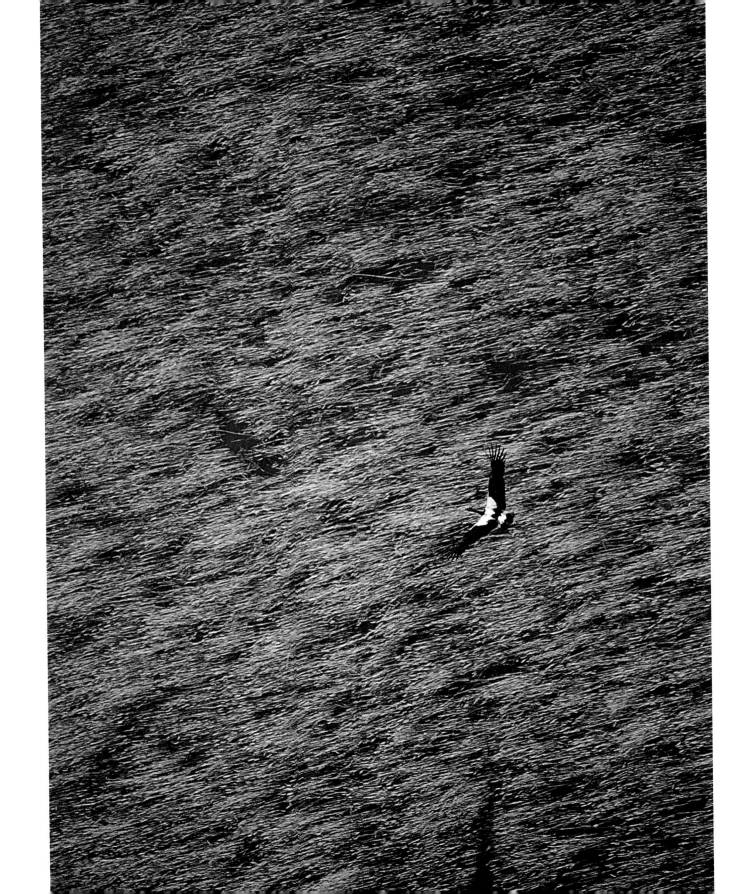

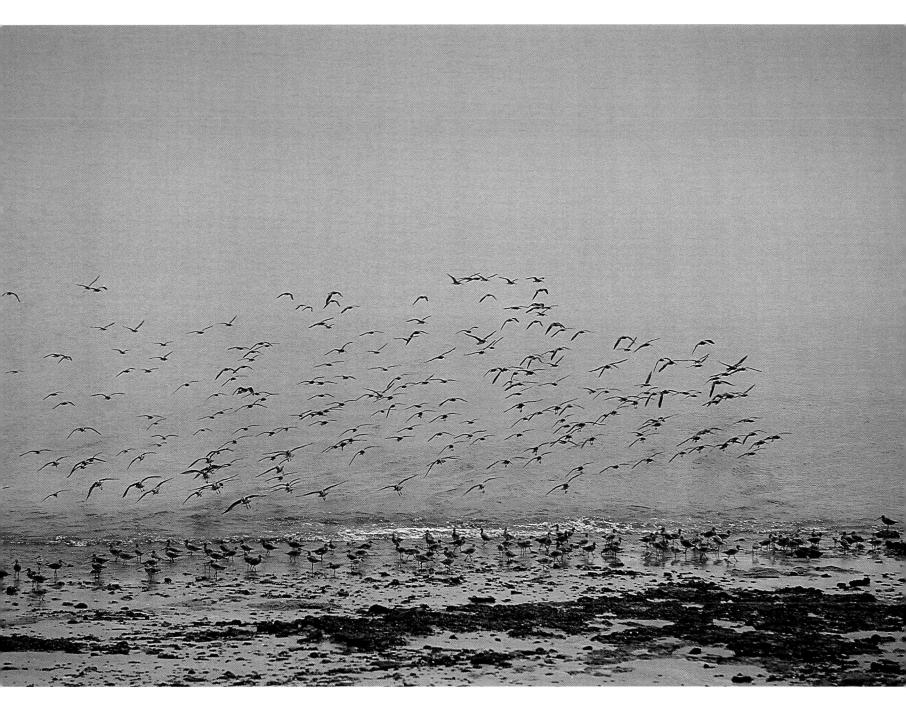

A single magpie goose soars over the wetlands.

People can observe the migration of birds to and from Siberia, from the bird observatory near Broome.

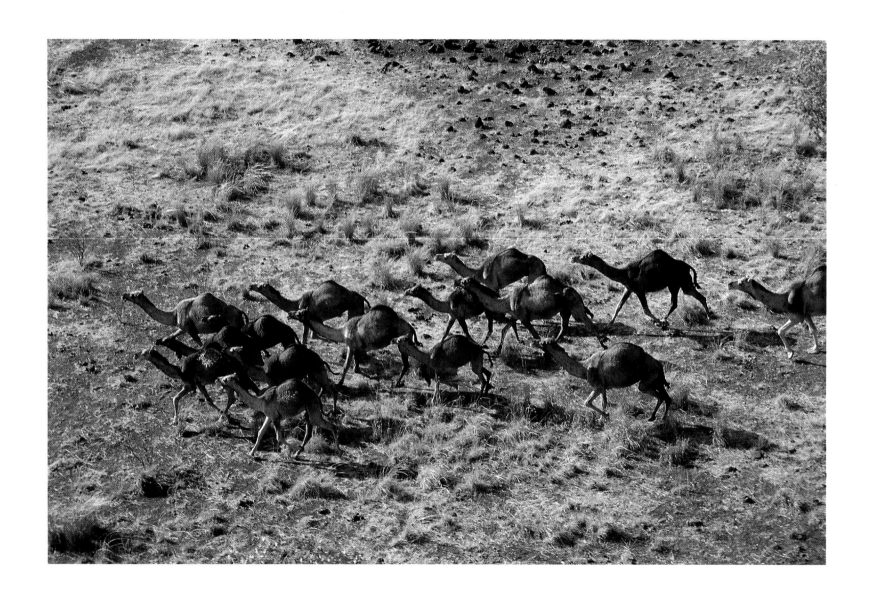

Camels, first introduced as a means of transport in remote areas, still roam the Kimberley, wild and free.

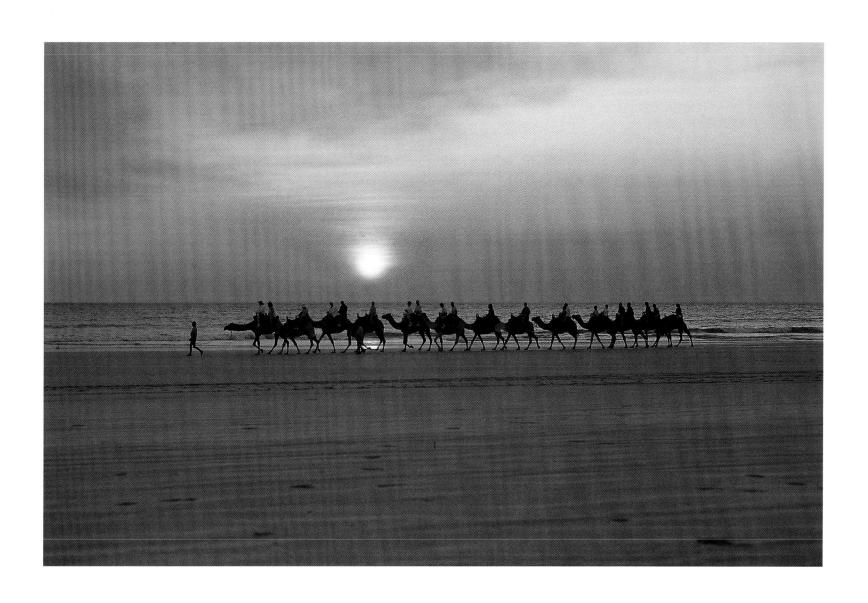

Overleaf: Coastline near Broome. The discovery of ancient dinosaur footprints has been made near here.

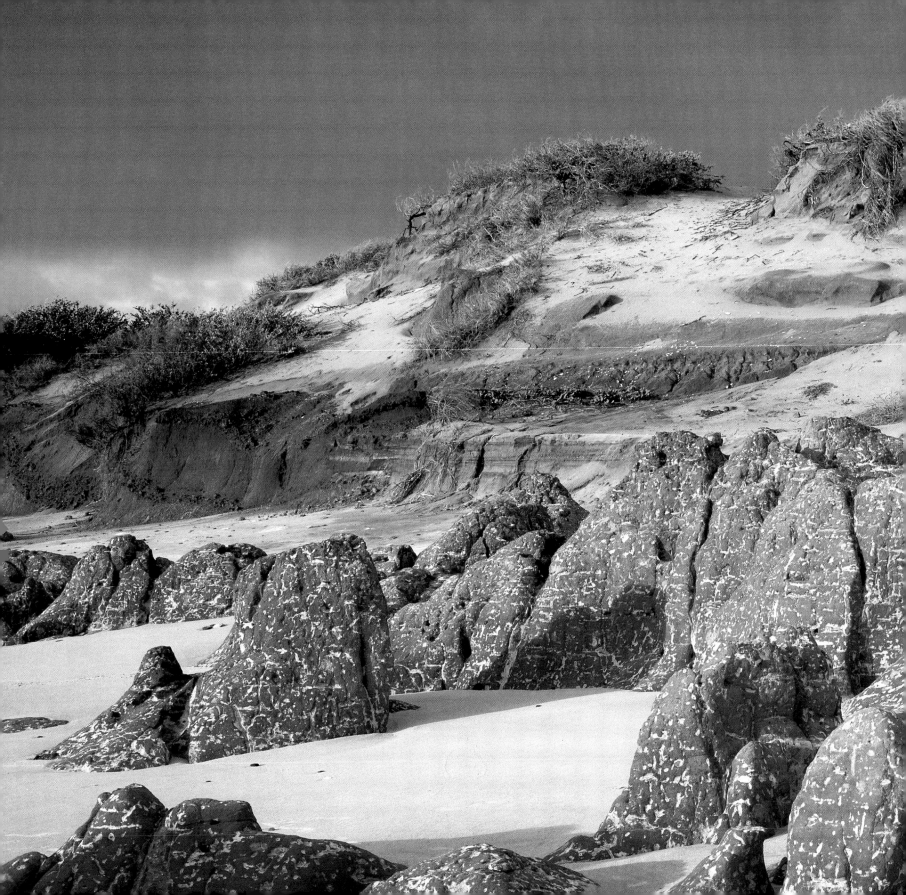

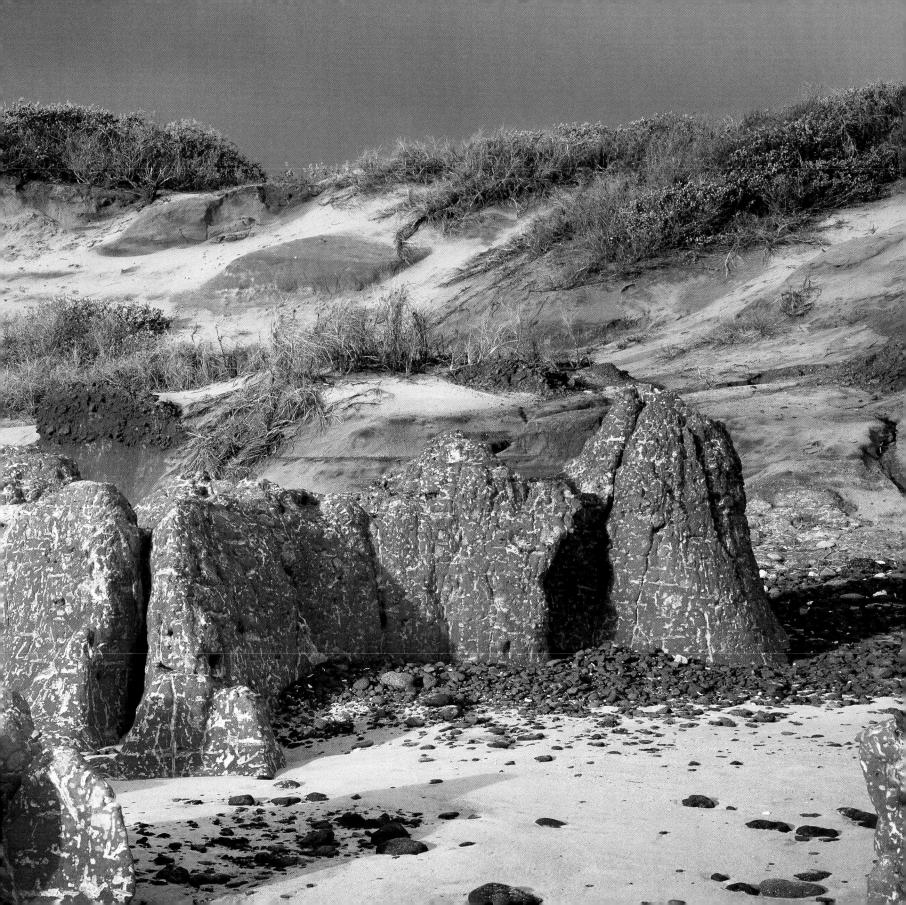

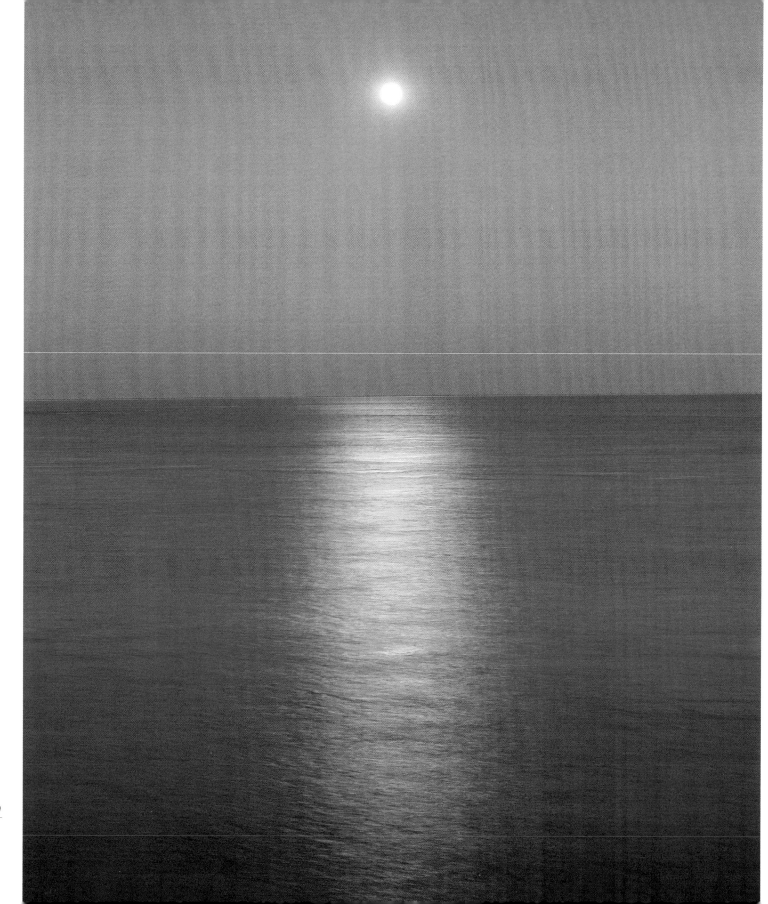

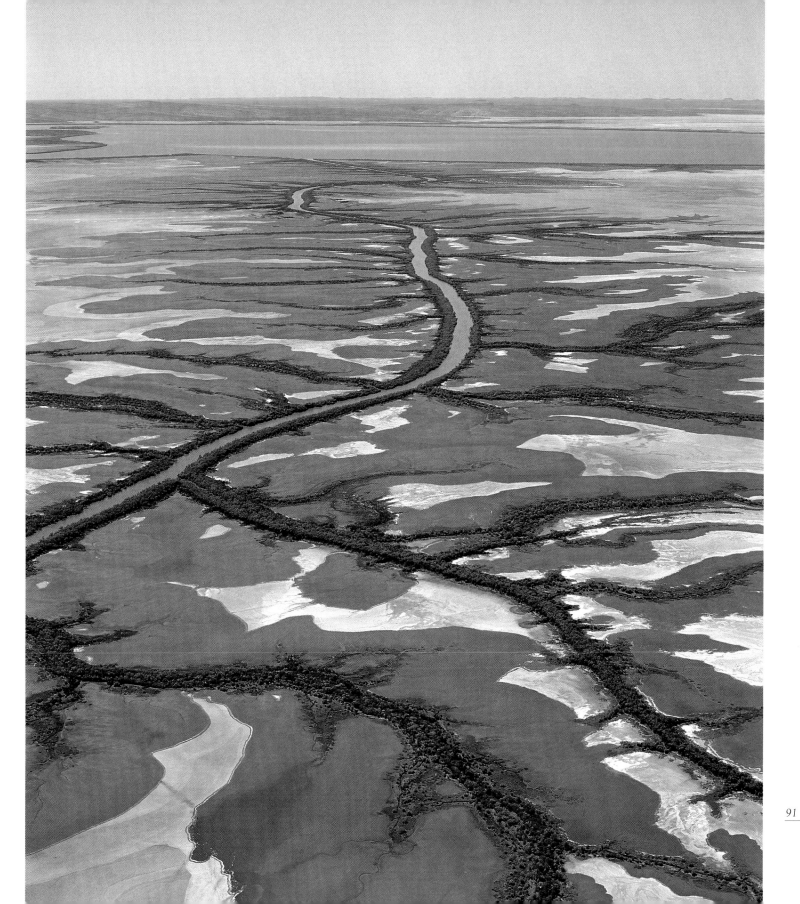

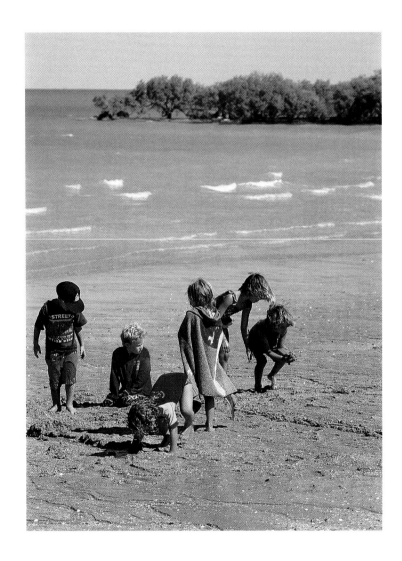

Children fossick and adults fish on the beach near Broome.

Page 90: A serene moon rises over the ocean at Broome.

Page 91: It is the tug of the moon which causes the huge tidal varia-
tions of the north (up to eight metres) that carve these tidal
patterns on the coastal flats near Wyndham.

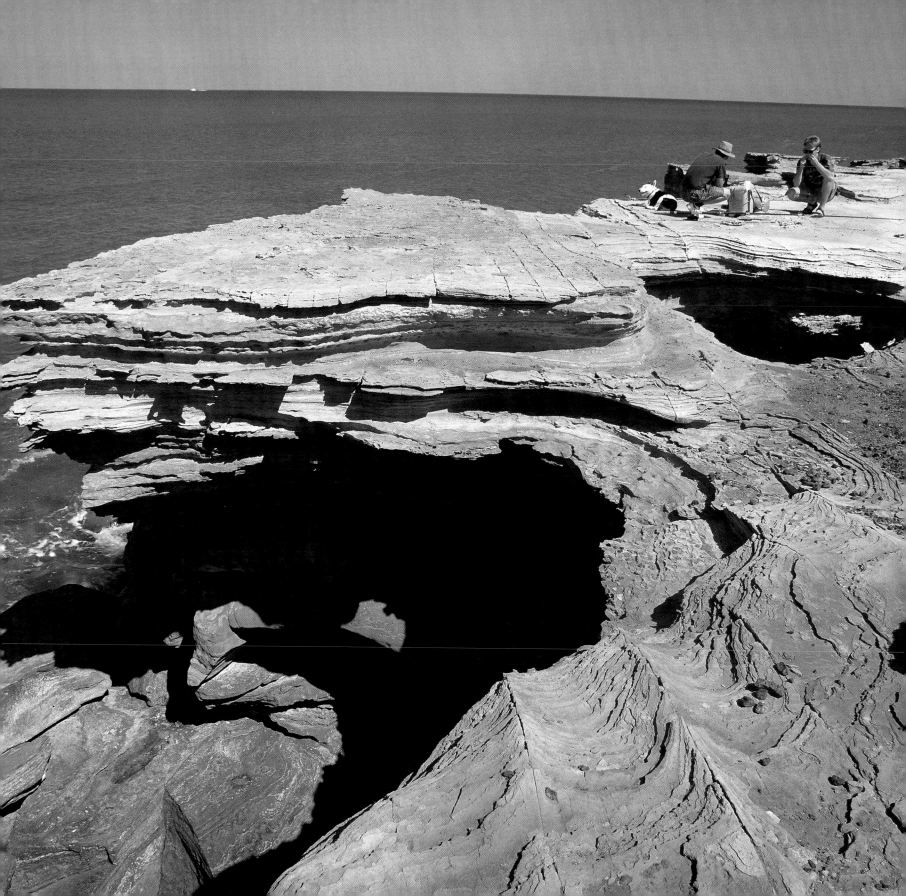

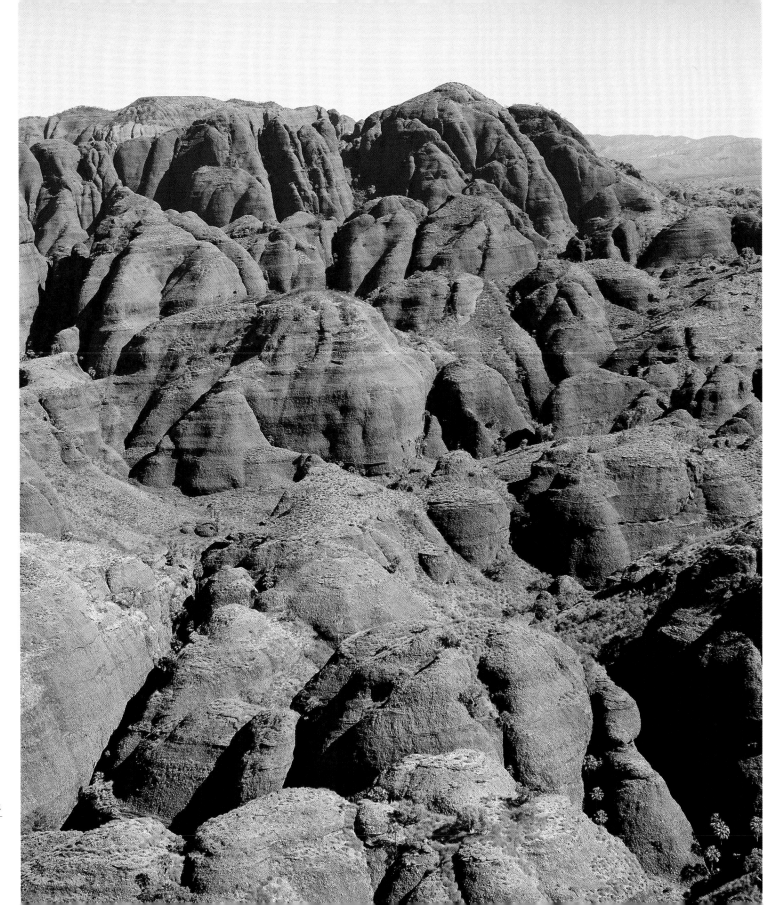

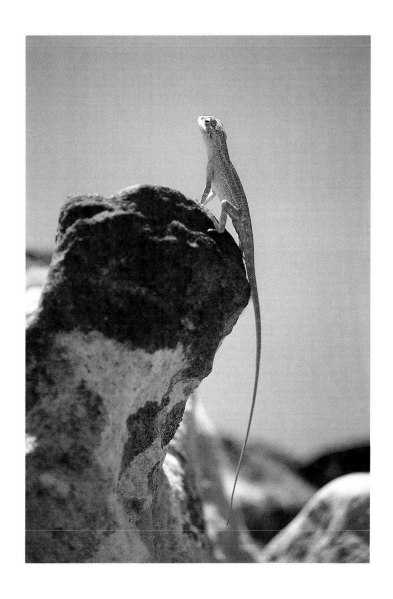

Ragged Range, west of Carr Boyd Range, Kimberley.

Close-up of a lizard sunning itself on a rock in the Bungle
Bungle, Purnululu National Park.

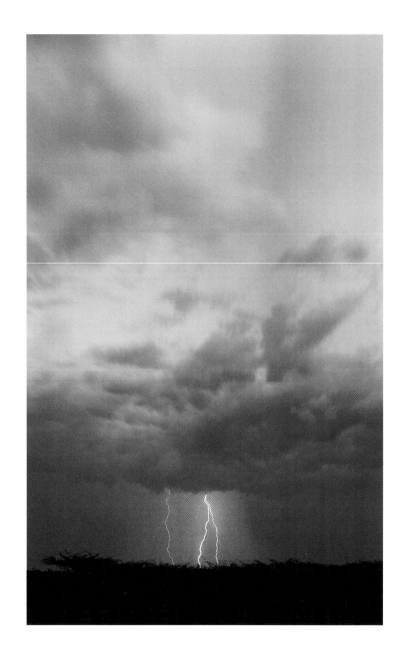

A theatrical event – the opening of the 'wet' season.

After the monsoonal downpour, the red-coloured pindan earth
streaks across the paler sands of Cable Beach, Broome.

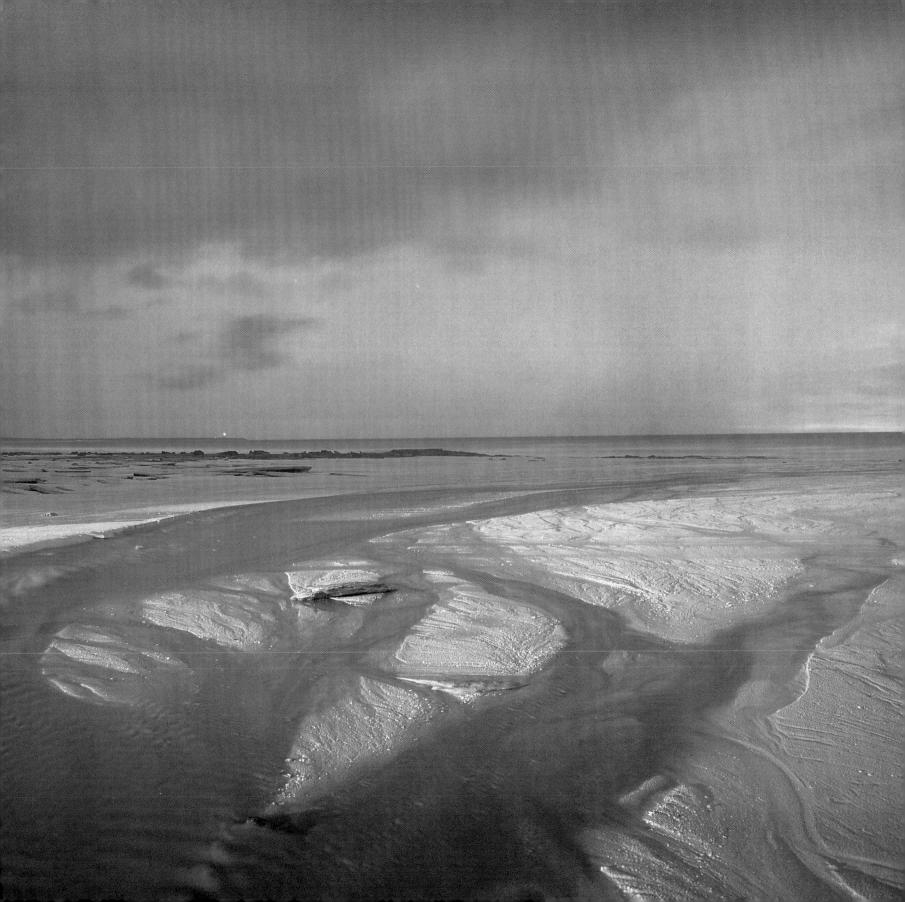

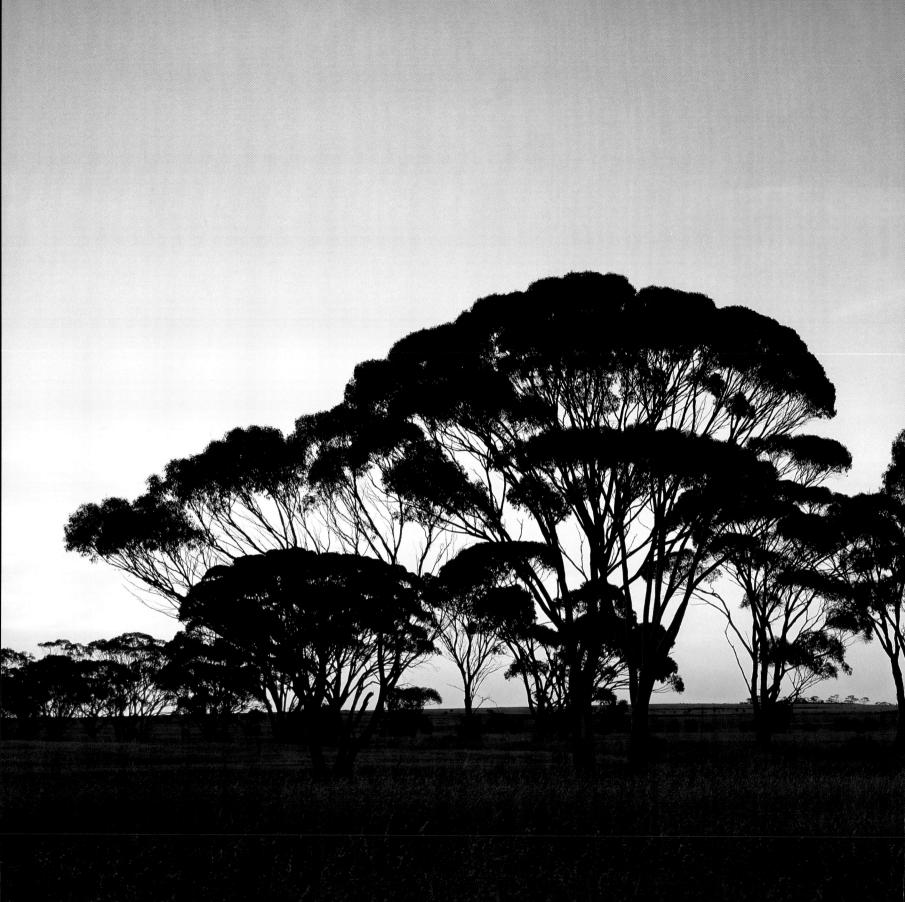

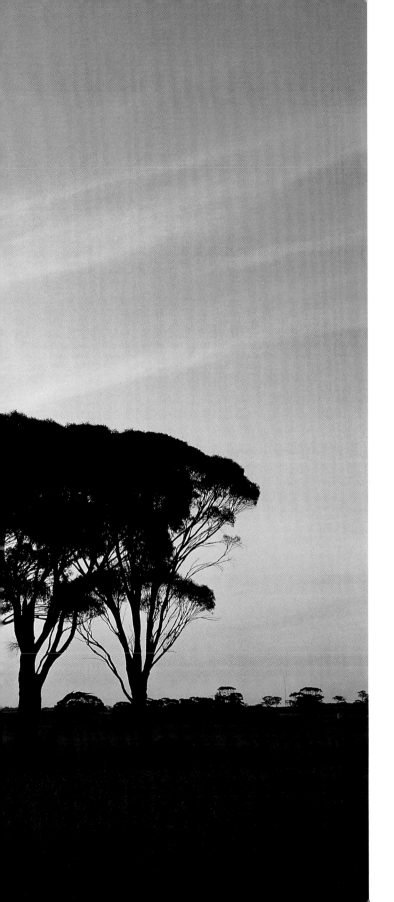

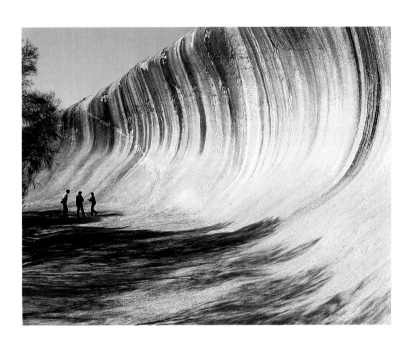

The elegance of eucalypts in the Wheatbelt.

Frozen surf – Hyden's giant Wave Rock.

The gimlet, one of the hardest woods in the world,
is common throughout the Eastern Goldfields.

Aerial view of saltbush country near Lake Lefroy,
south of Kalgoorlie.

Overleaf: Everlastings on Ningham Station near Payne's Find.

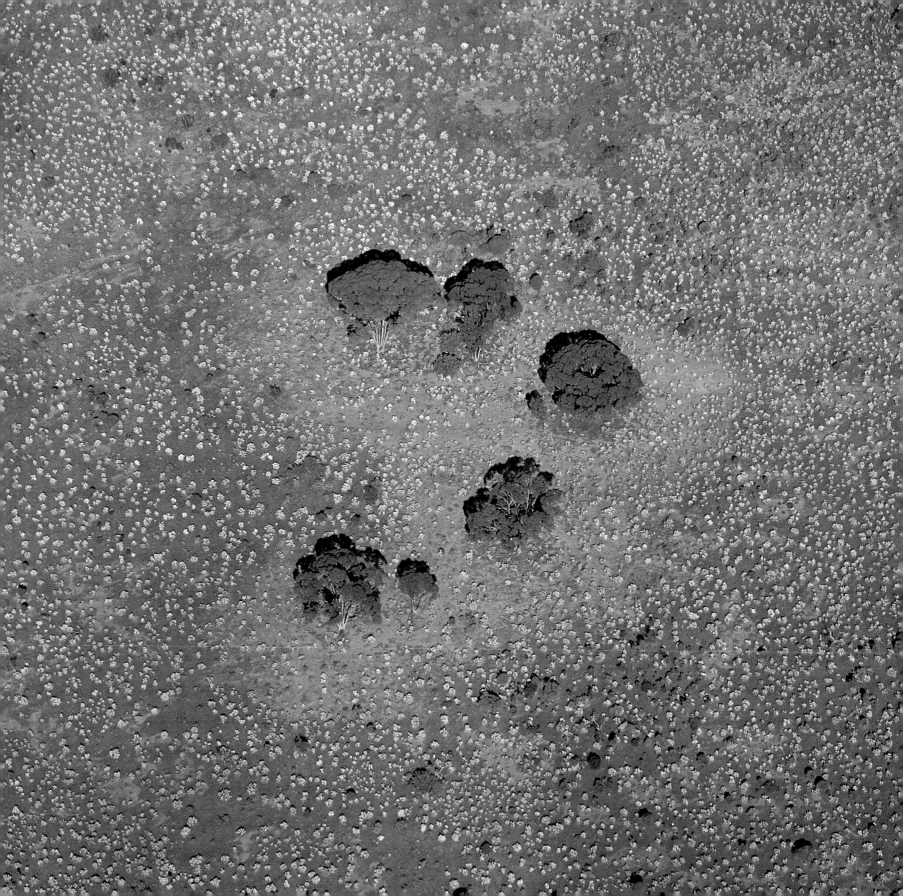

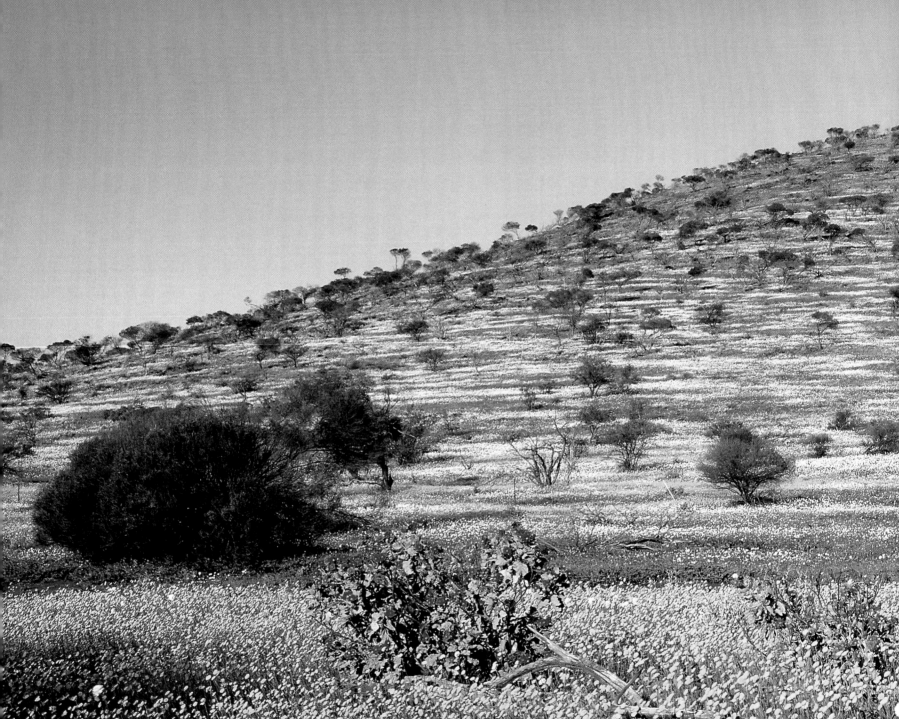

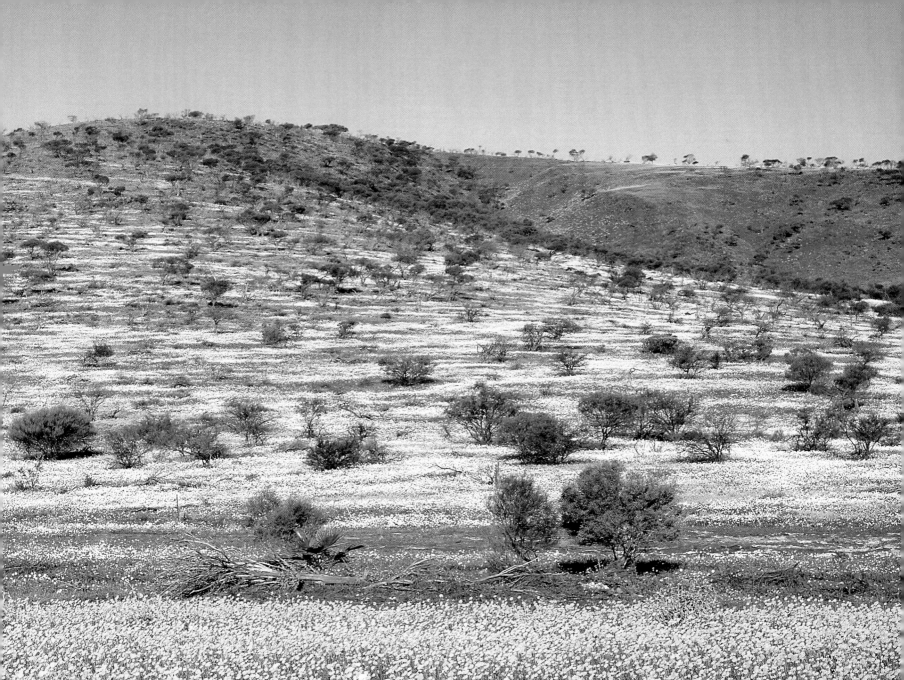

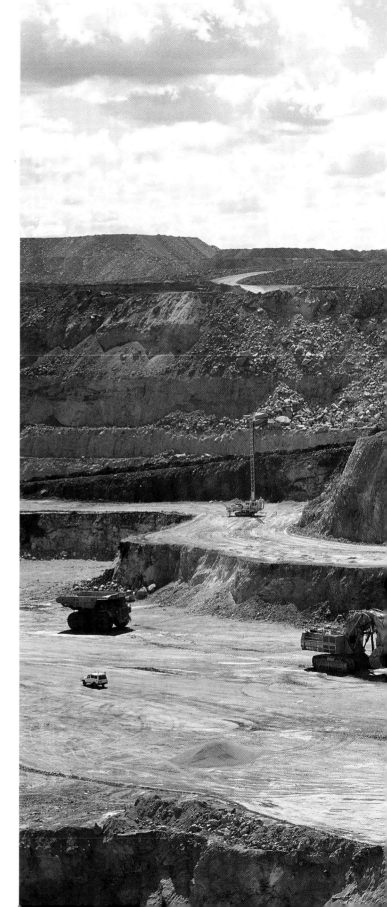

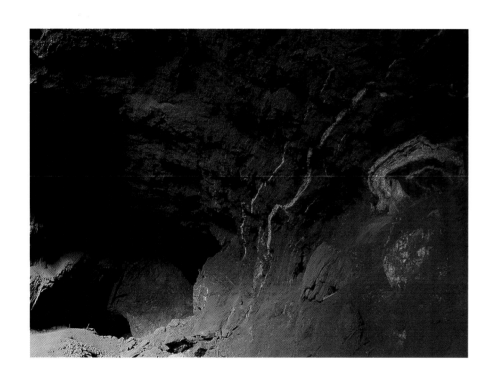

Mining operations, ancient and modern.

Aboriginal ochre mine near Cue.

The Super Pit goldmine at Kalgoorlie.

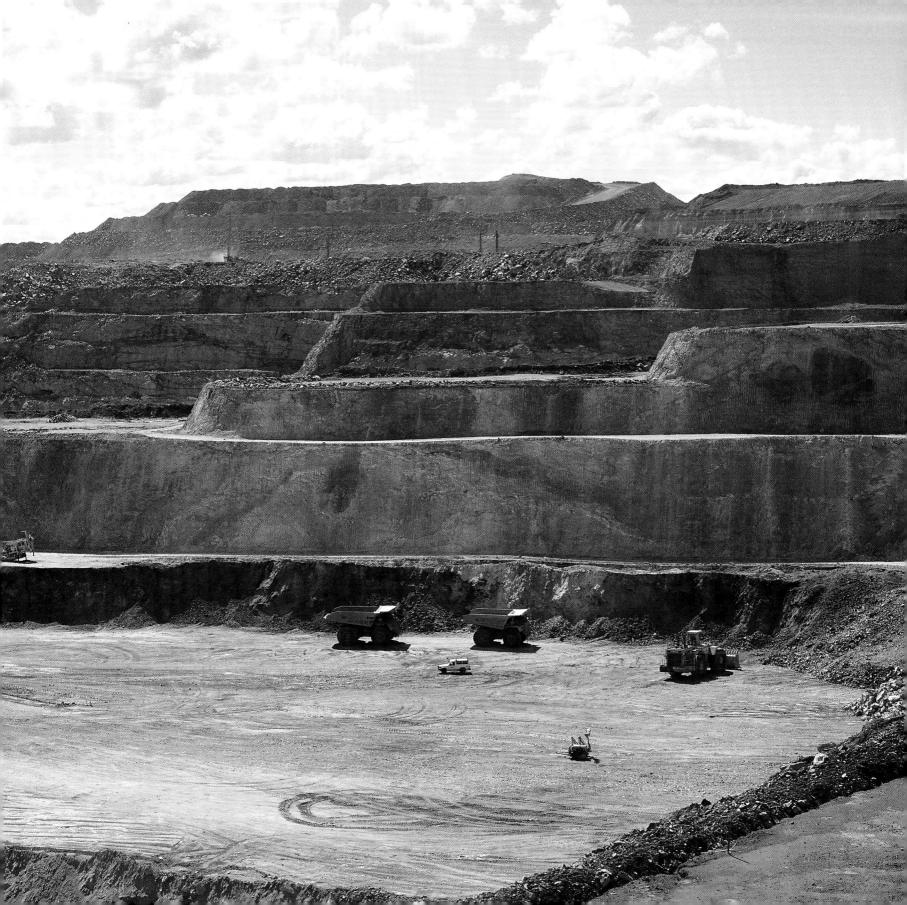

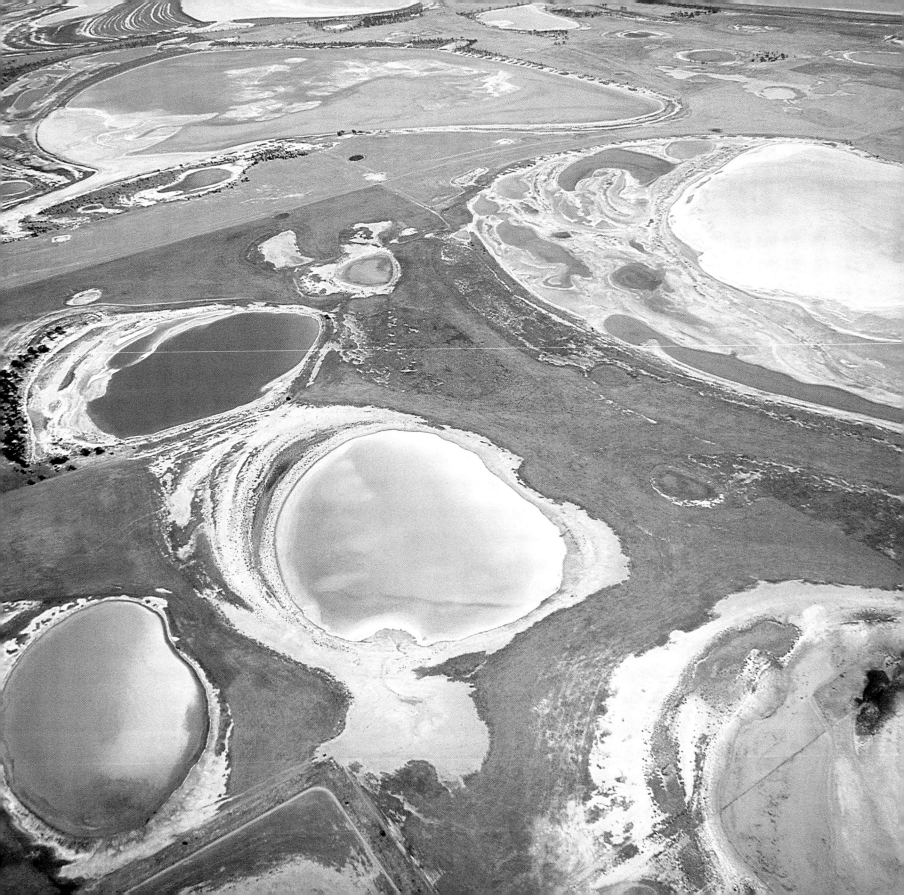

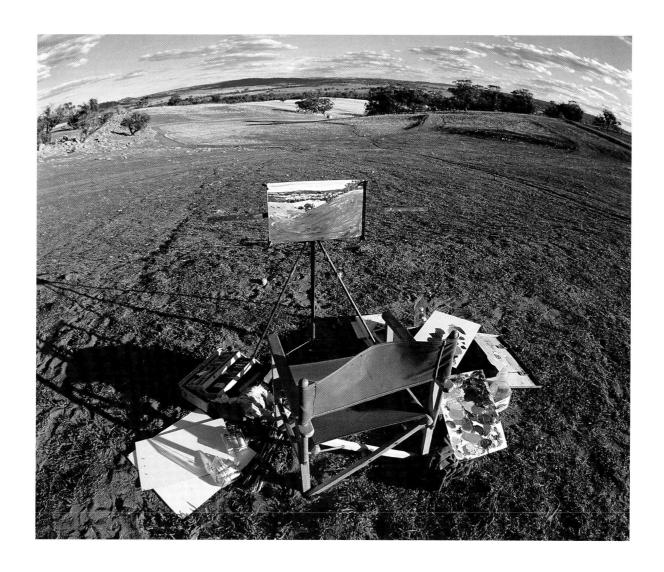

Nature's palette is so often an inspiration for the human painter.

Overleaf: Salt lakes of the Eastern Wheatbelt.

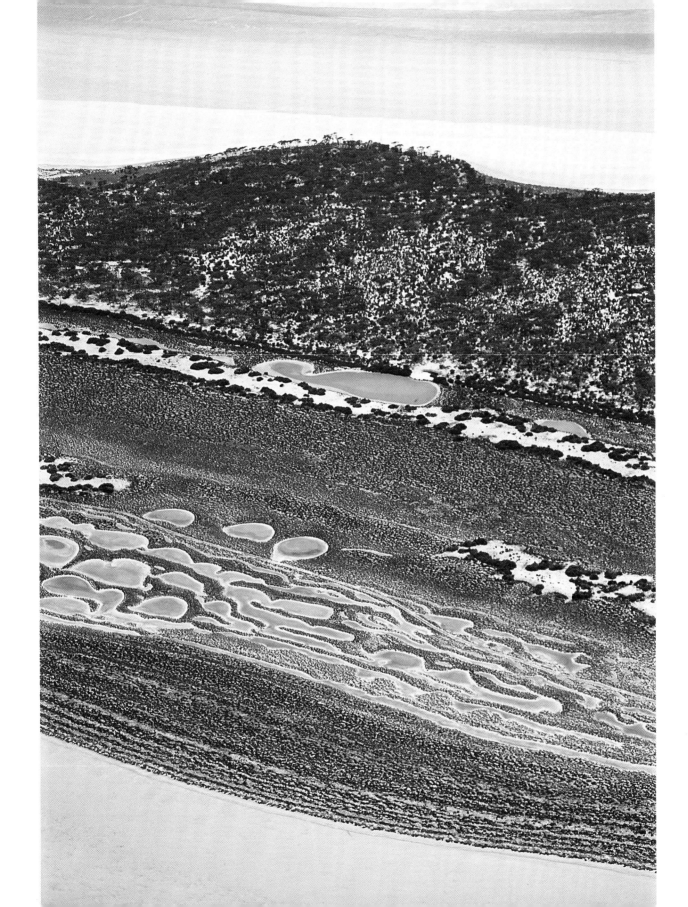

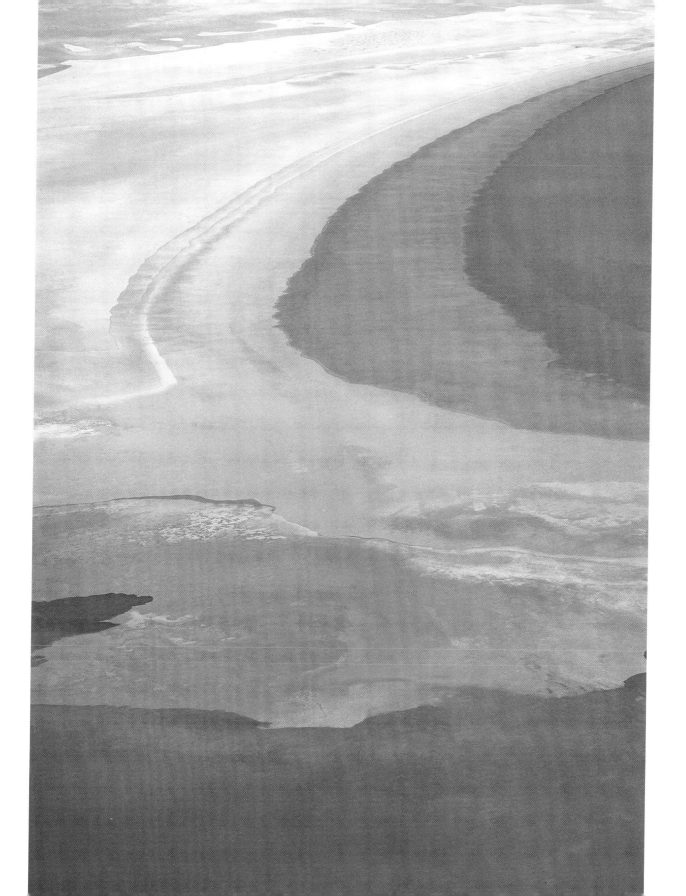

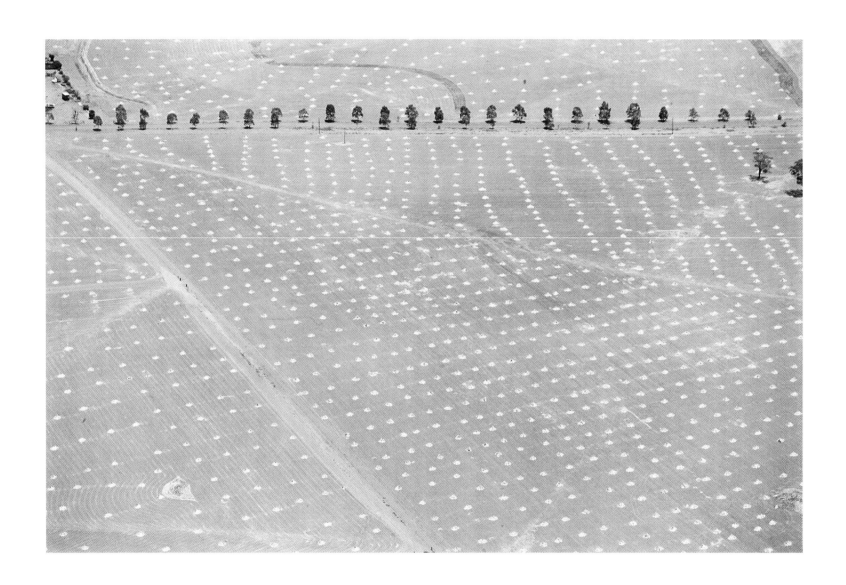

Aerial pattern created by wheat stacks drying in the sun.

Sheep and their shadows meandering across the land.

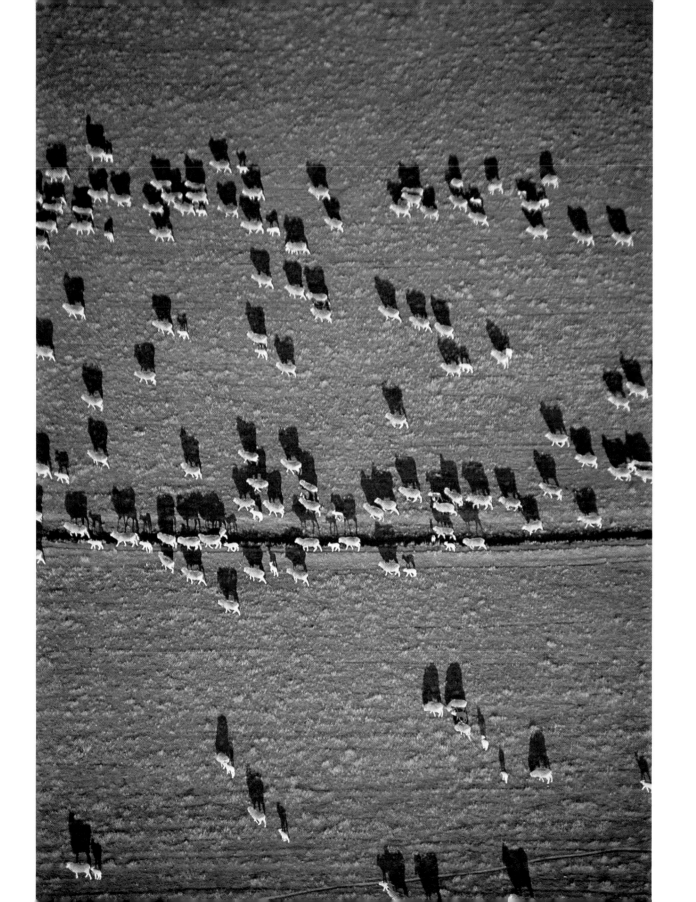

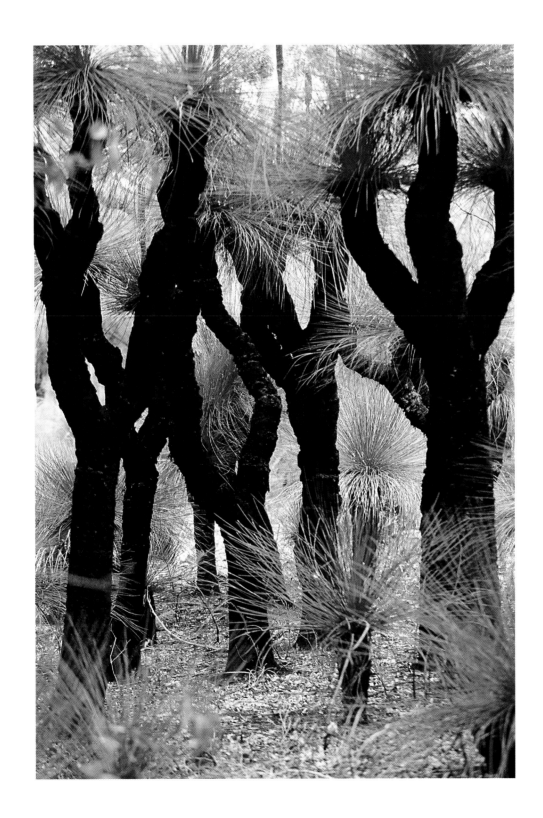

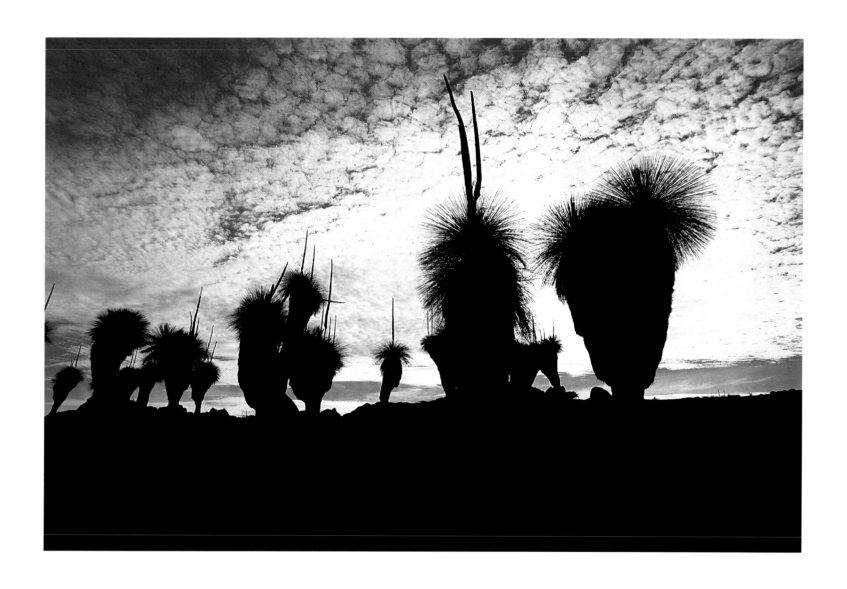

The grasstree or blackboy, a primeval form of vegetation. Blackened by the passing of countless fires, they form strange silhouettes.

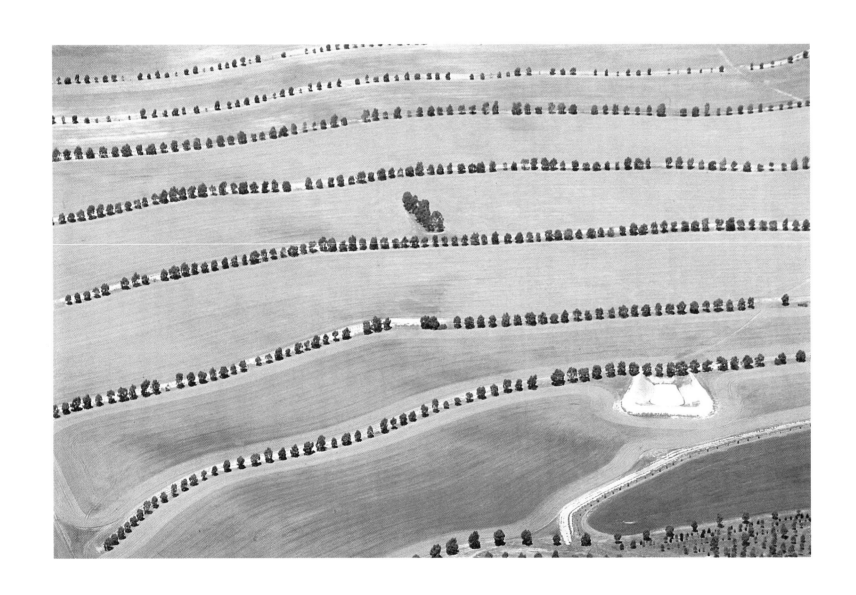

Farmers replace the trees, originally stripped from the land by clearing operations, in widespread planting programs.

Plough patterns drawn by the farmer after the rains.

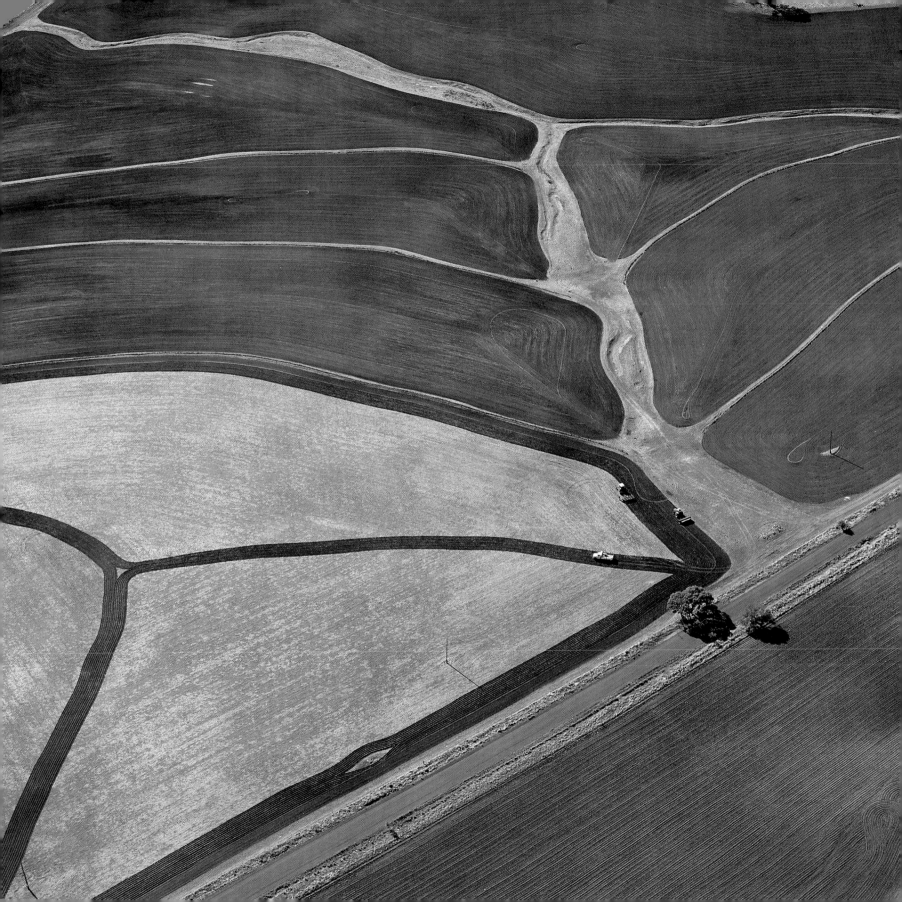

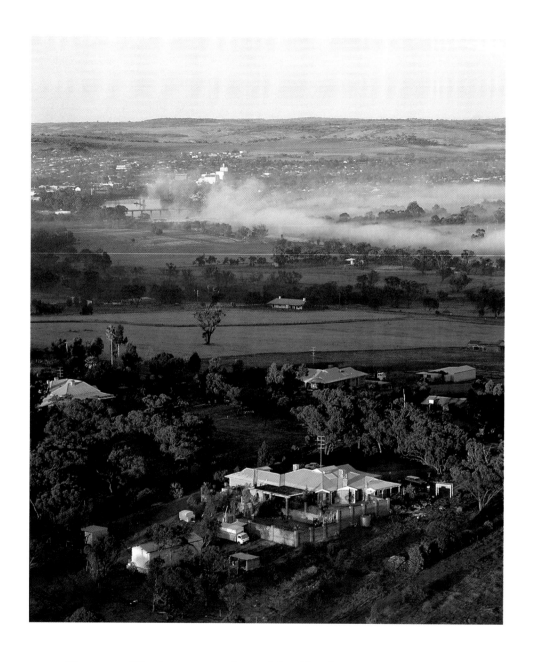

The town of Northam, centre of one of the oldest farming areas of the State.

Farmlands near York.

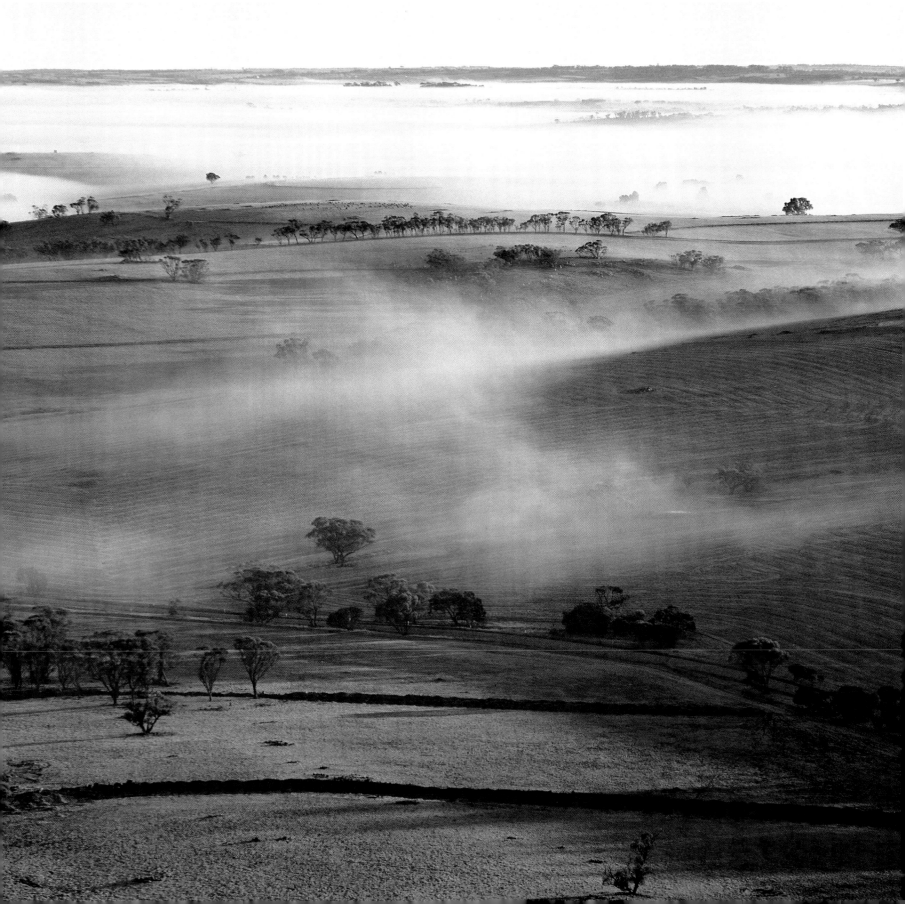

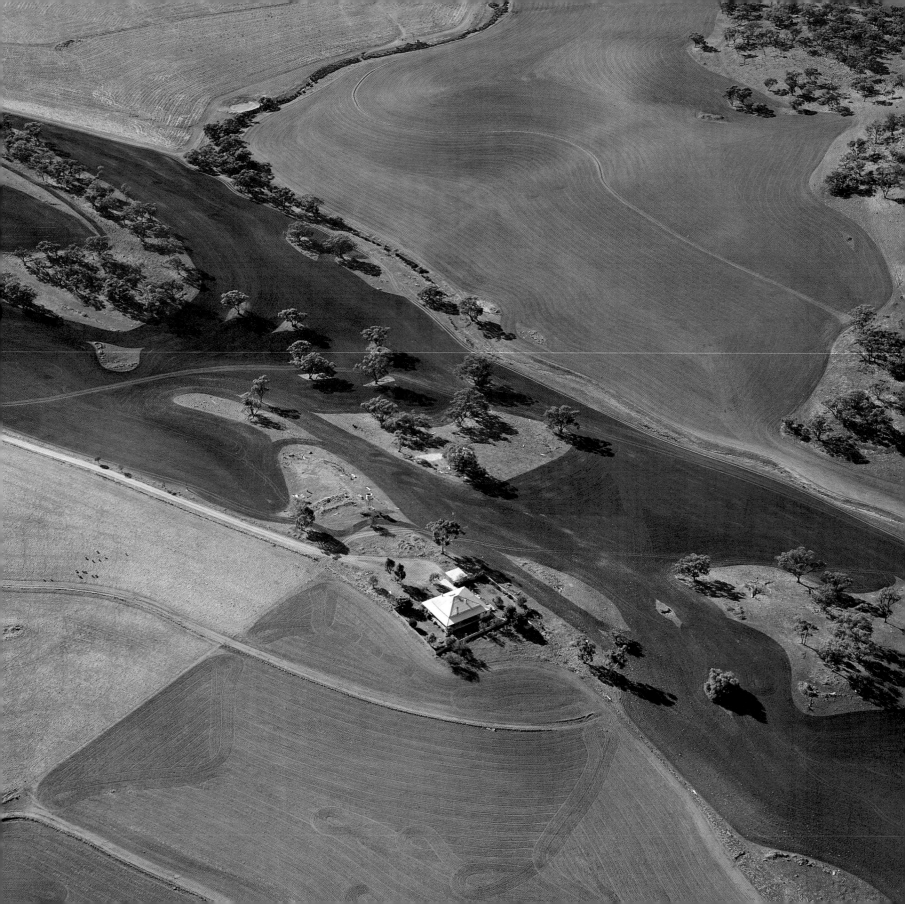

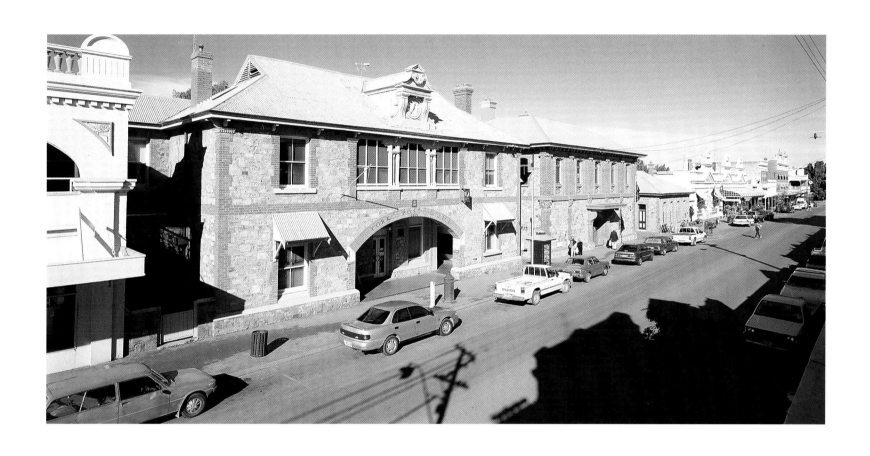

Main street of York.

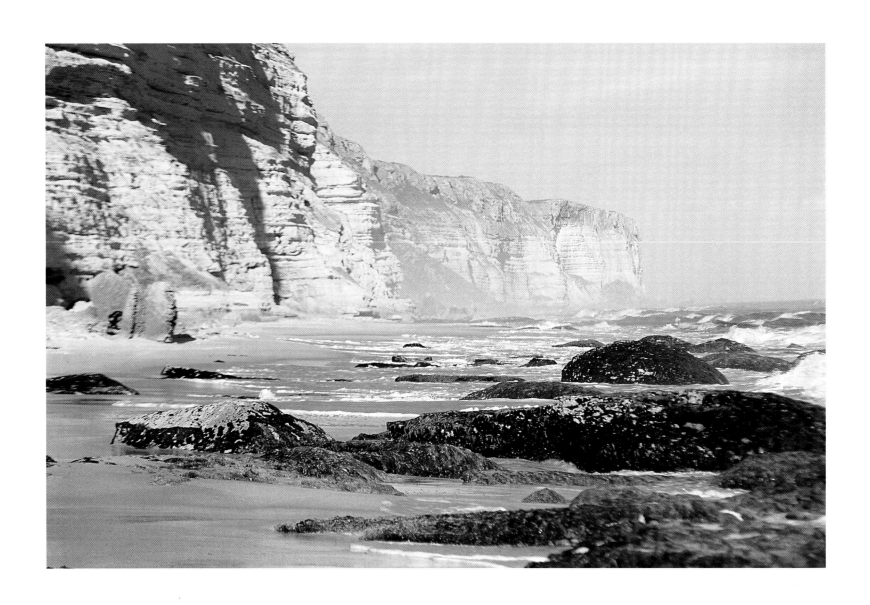

Baxter Cliffs on the southern edge of the Nullarbor Plain.

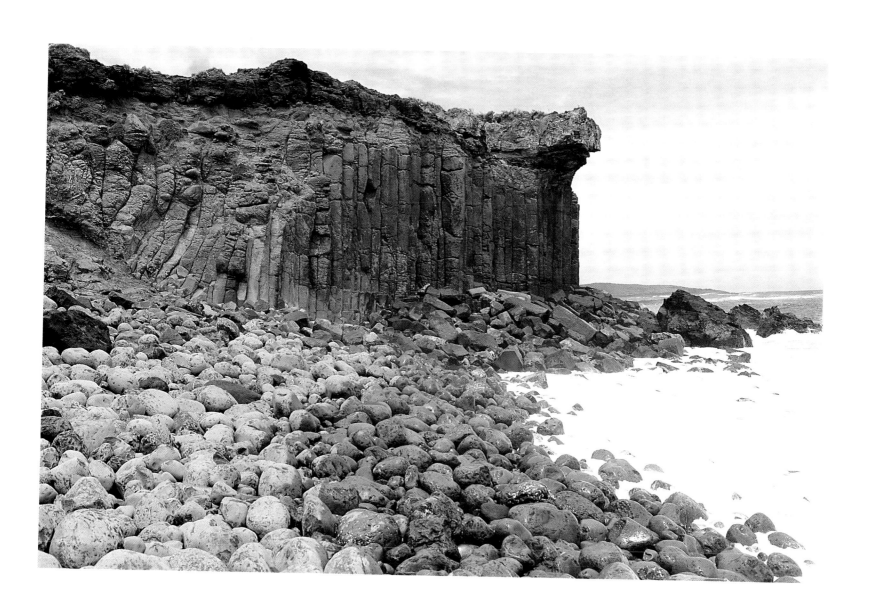

Black Point — coastline east of Augusta.

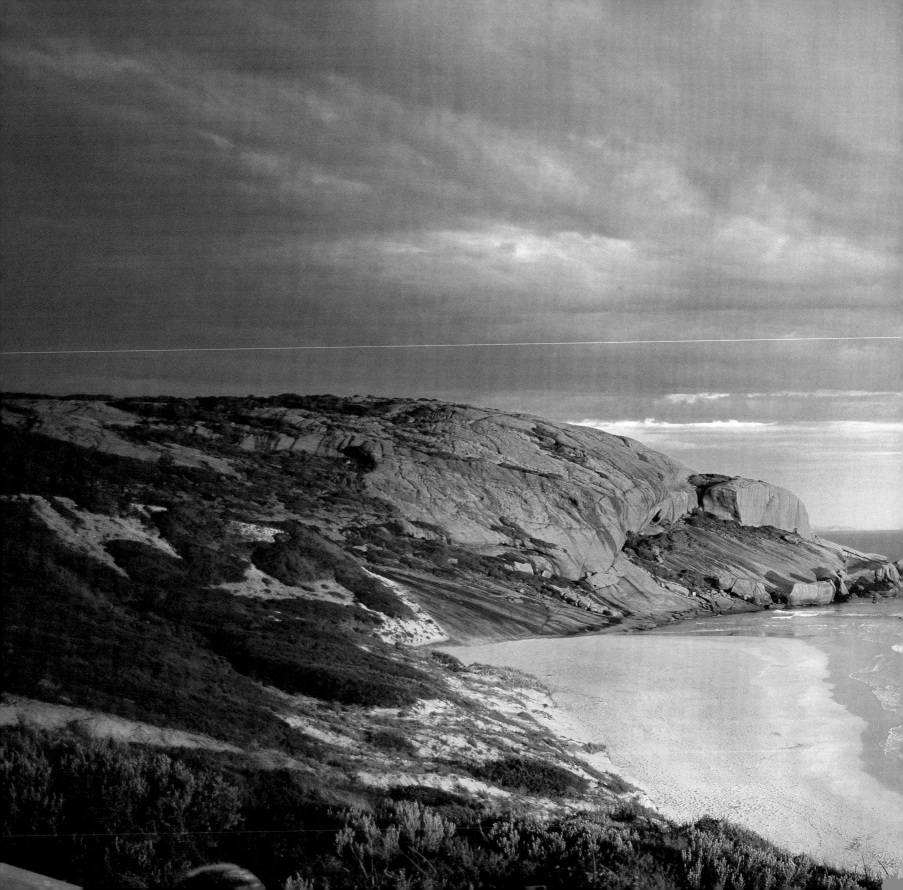

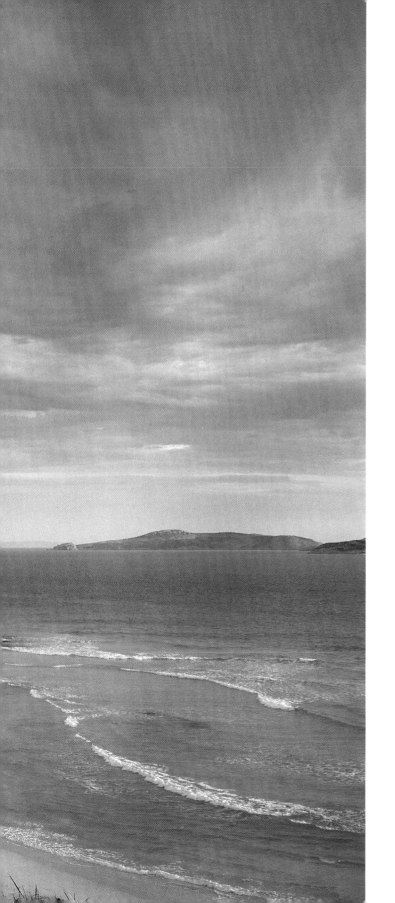

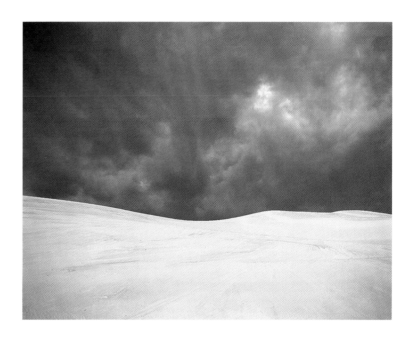

Twilight Bay, Esperance.

123

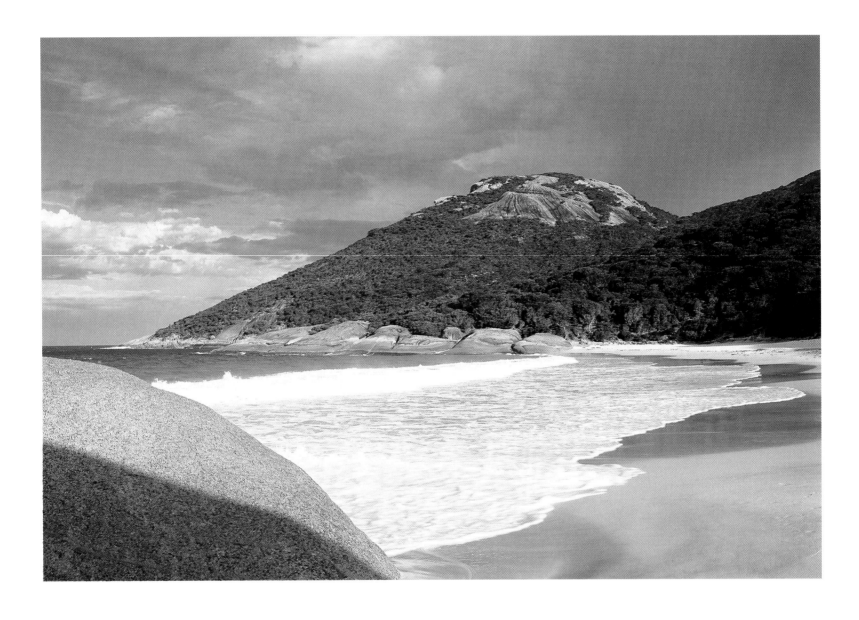

Two People Bay, Albany.

Nornalup Inlet, near Walpole.

Overleaf: Canal Rocks, south of Yallingup.

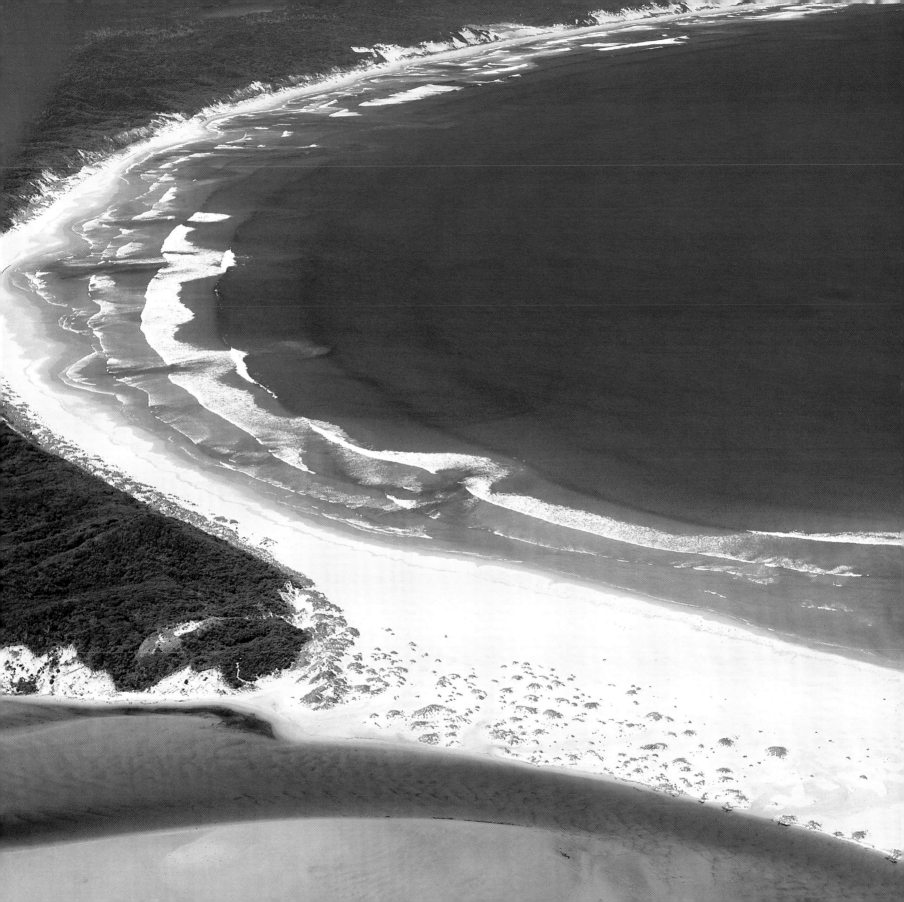

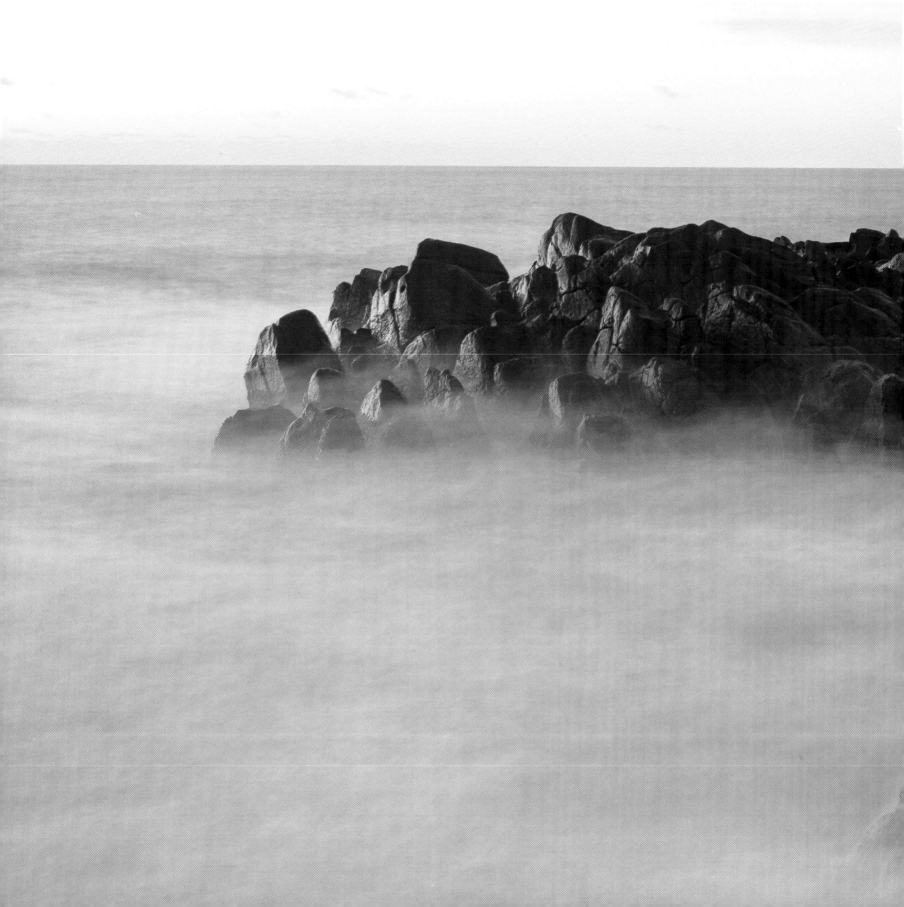

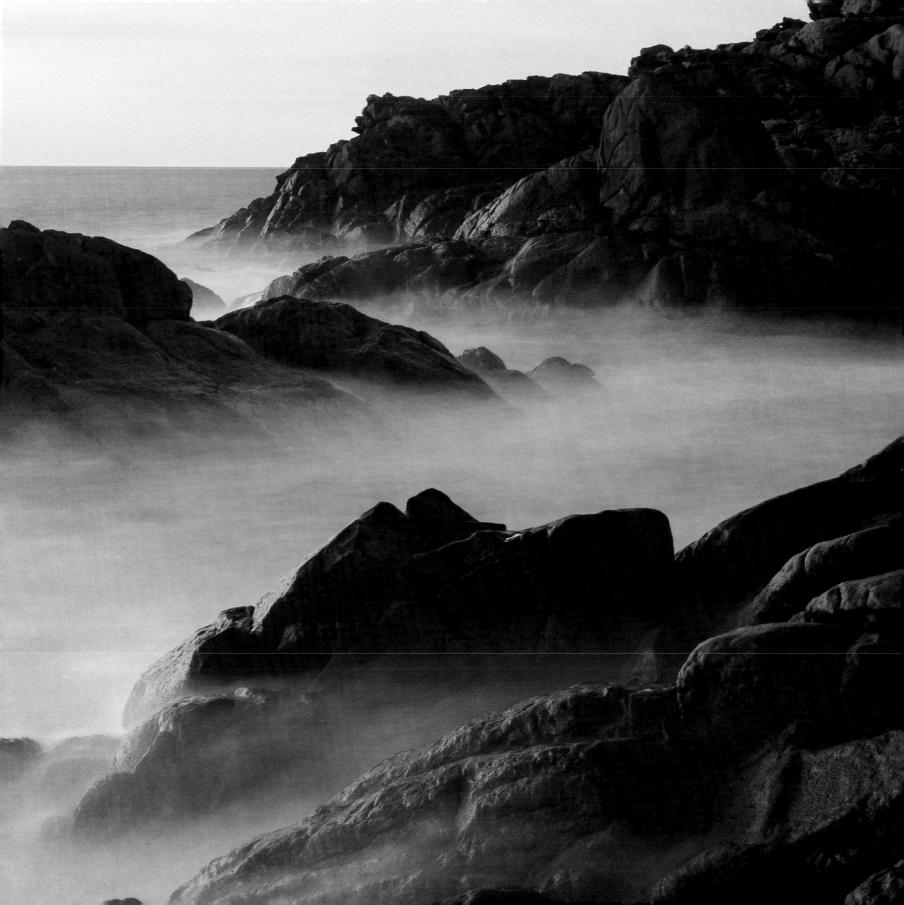

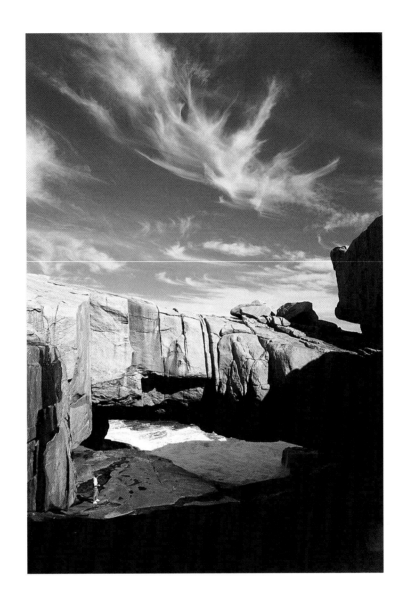

The Natural Bridge, Albany.

Early evening, Princess Harbour, Albany.

Overleaf: Sunset, Wilsons Inlet, Denmark.

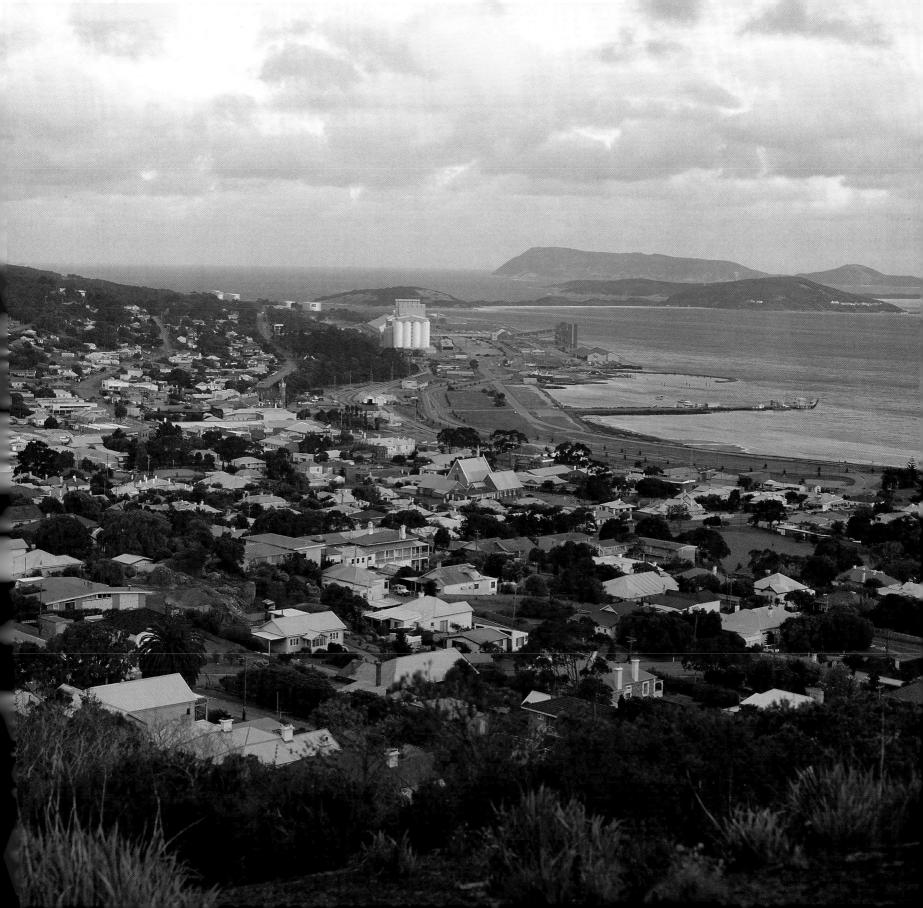

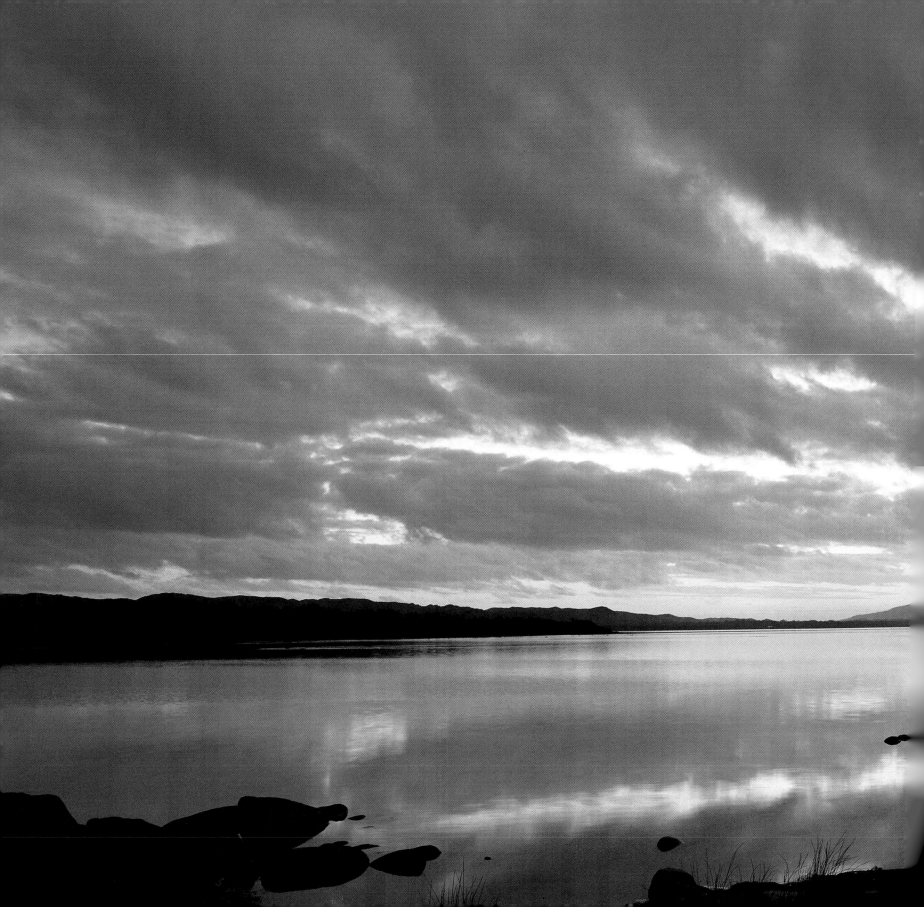

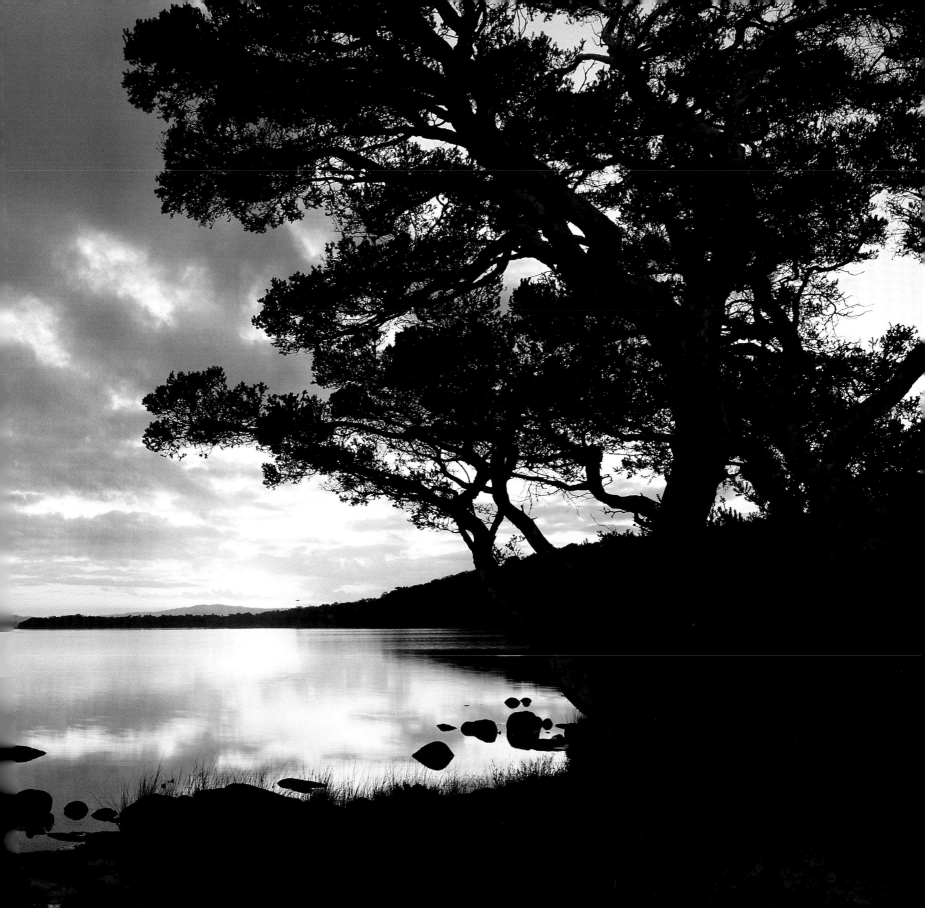

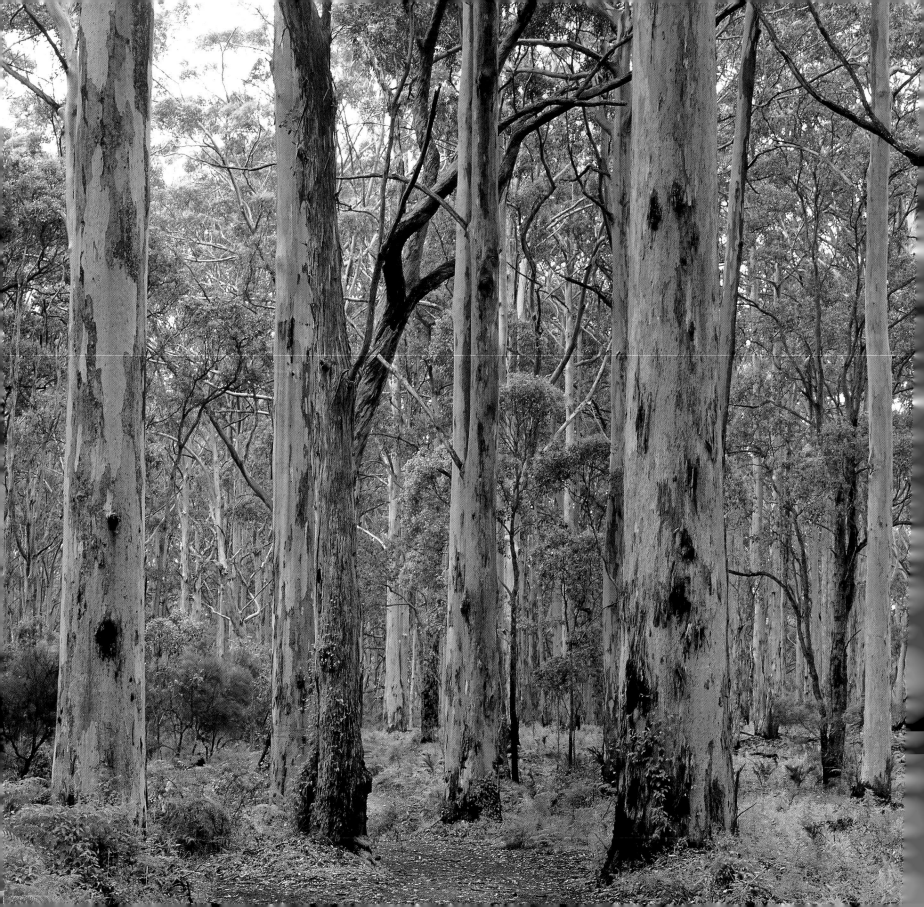

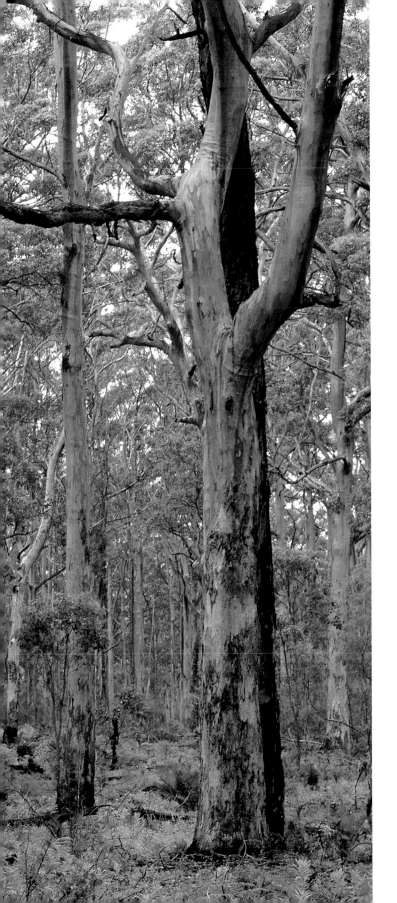

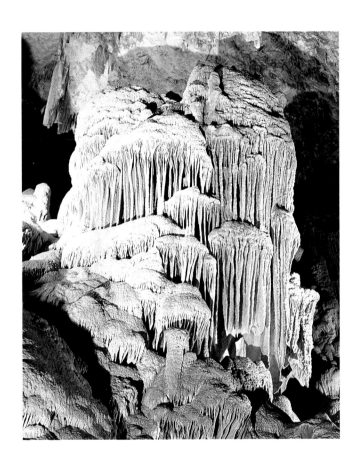

Karri forest. The karri is the tallest tree growing in
Western Australia.

A slower kind of growth occurs underground.
Stalactites in Jewel Cave at Margaret River.

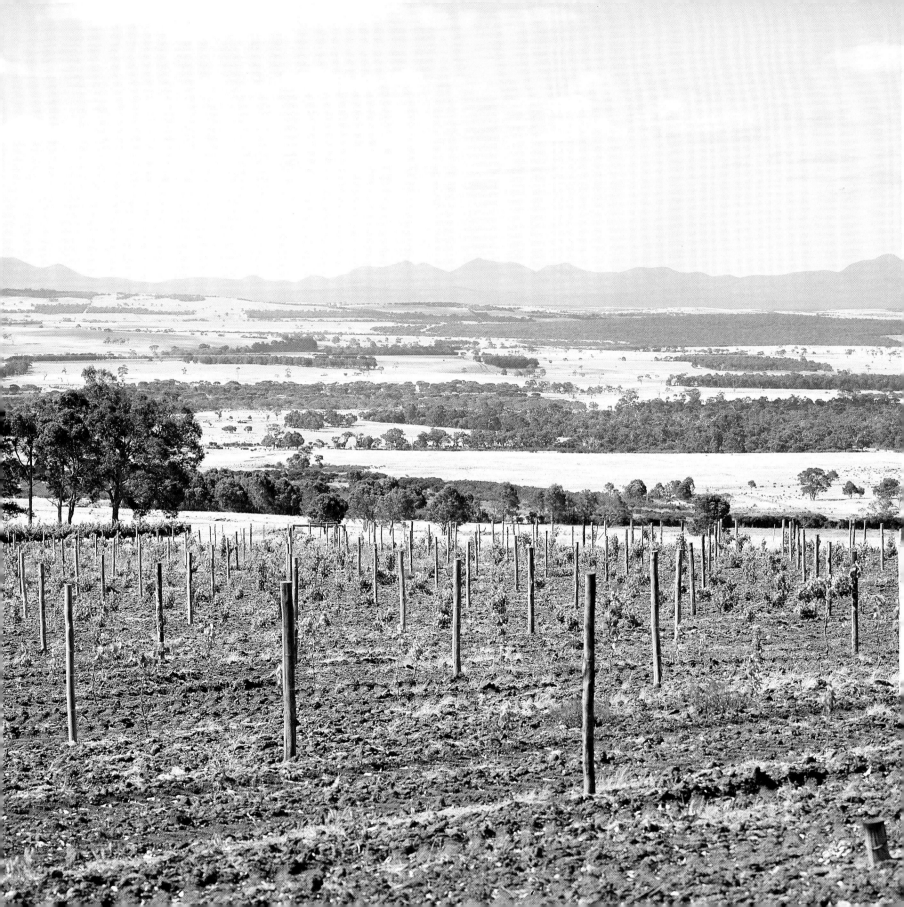

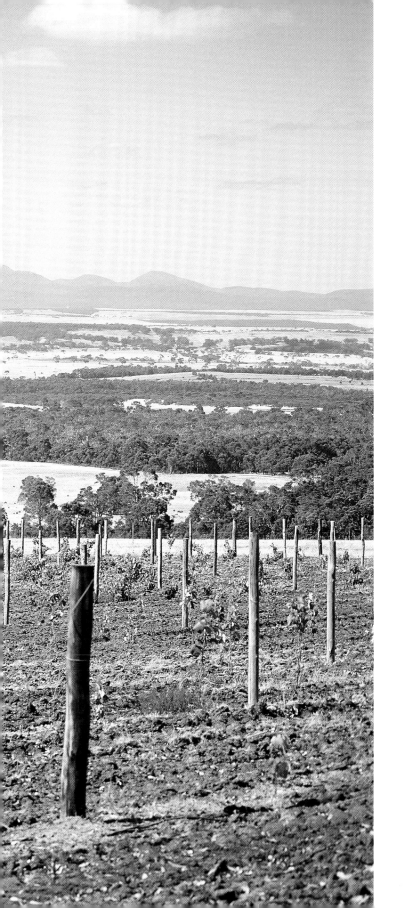

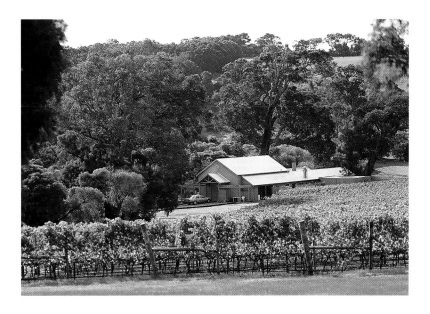

A vineyard in the making. New wine grape plantings near the
Porongurups.

An older, established vineyard in the Margaret River region.

Overleaf: The Stirling Ranges emerging from
a field of canola.

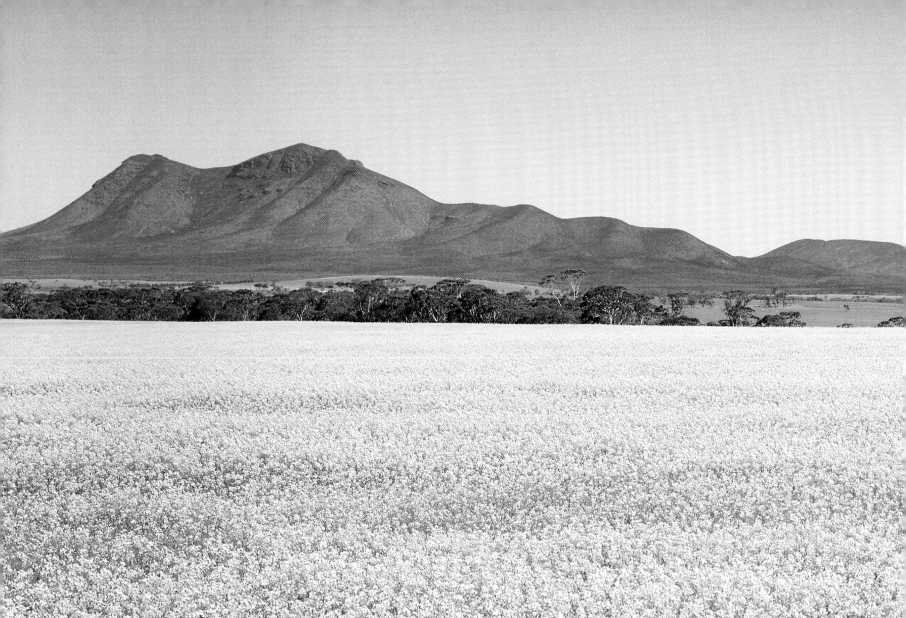

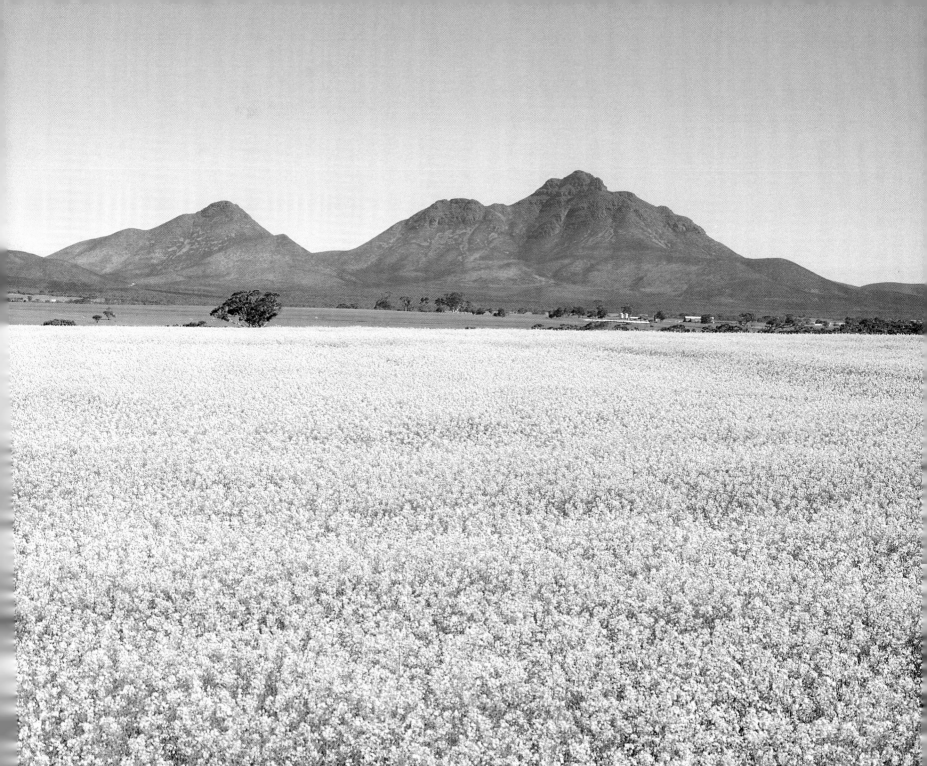

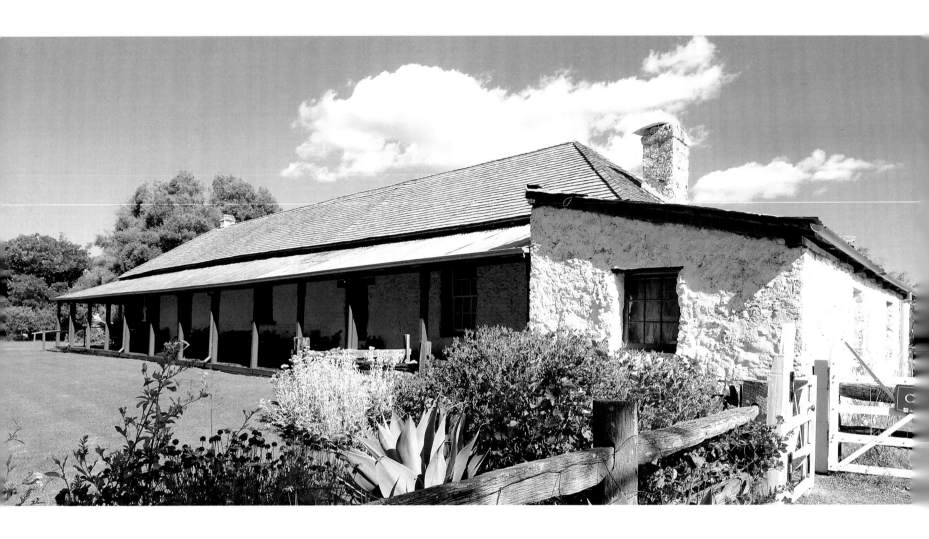

Wonnerup House, a pioneer homestead near Busselton.

Canoeing through the karri forest.

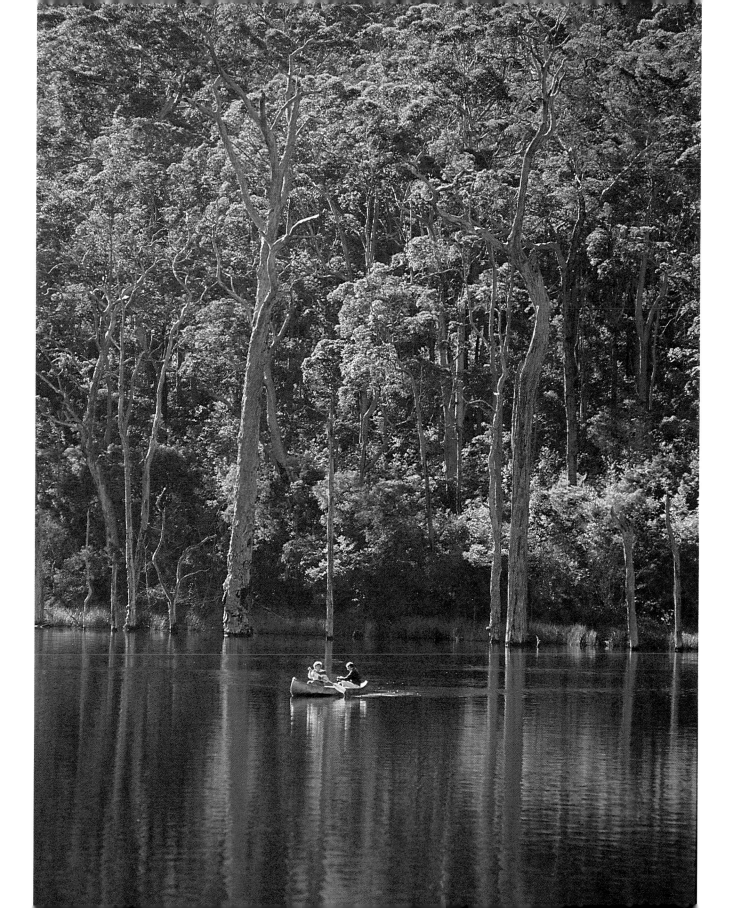

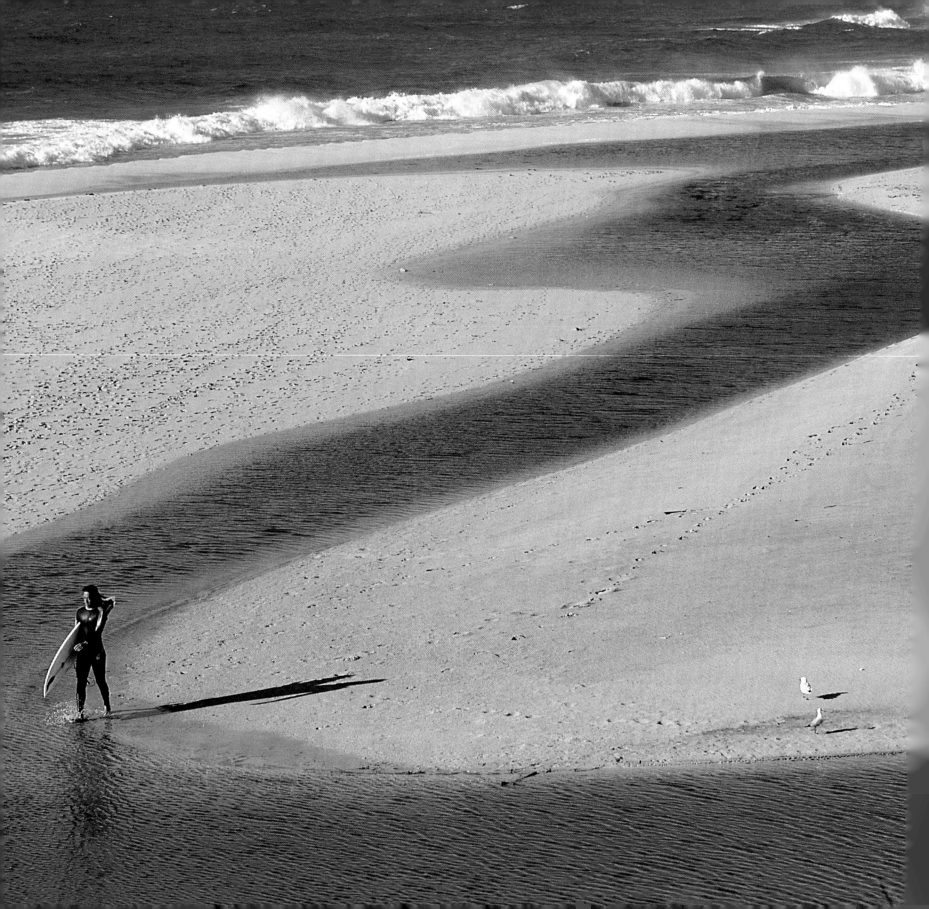

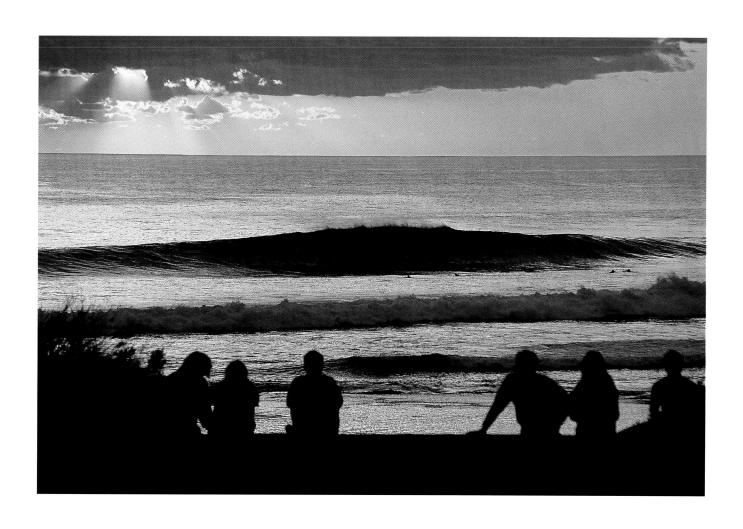

The south-west corner of Australia boasts some of the best surfing beaches in the world.

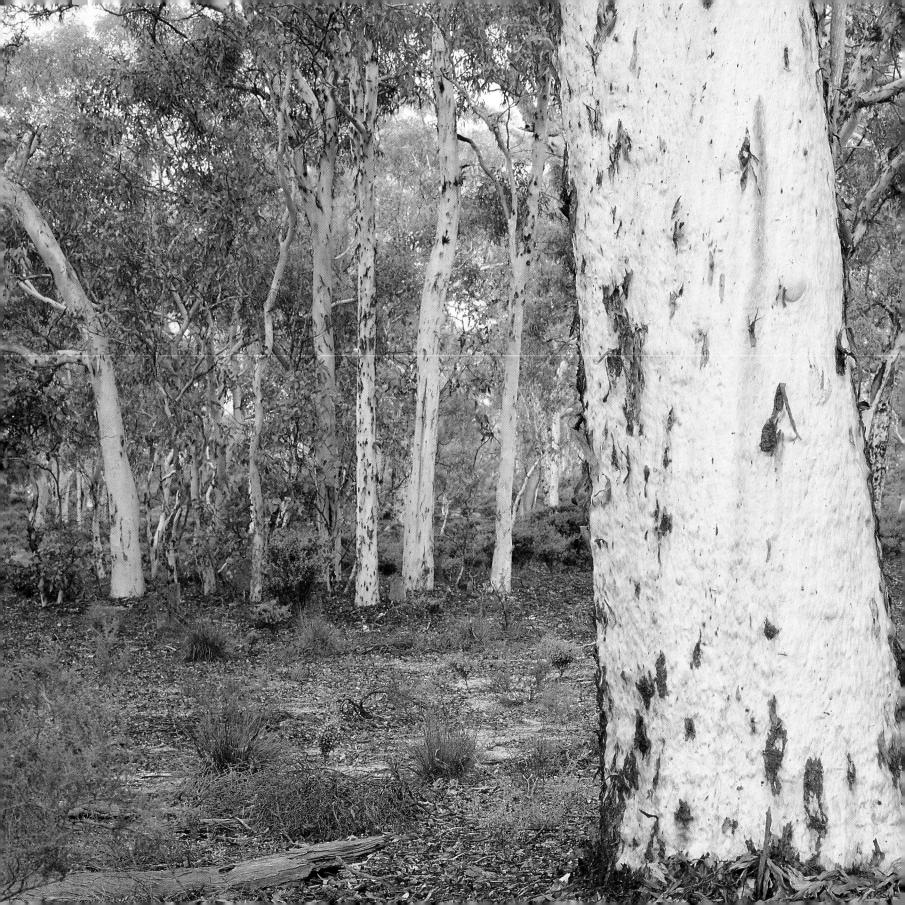

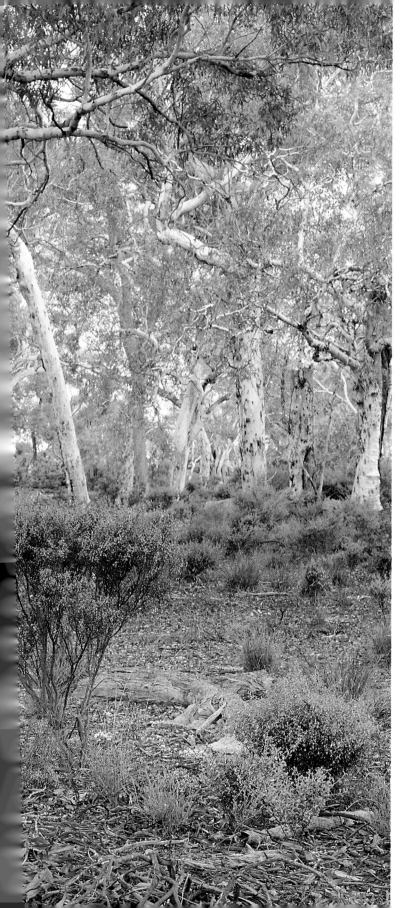

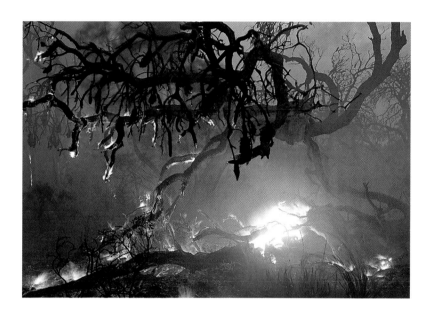

Australia is the driest continent in the world and bushfires are a constant threat during the long, hot summers.

Many of the native plants, such as the eucalypts, have developed a resistance to the onslaught of the flames that regularly sweep through the bushland.

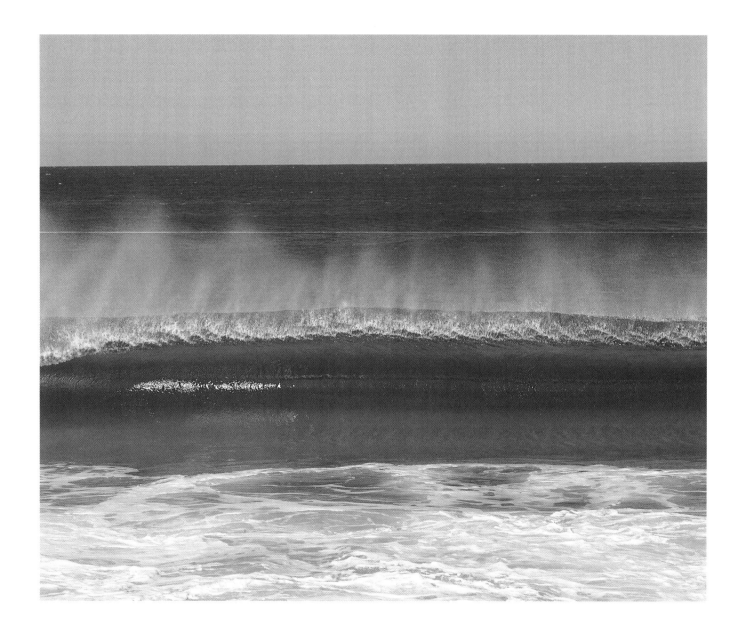